IMAGES
of America

NAPA

AN ARCHITECTURAL WALKING TOUR

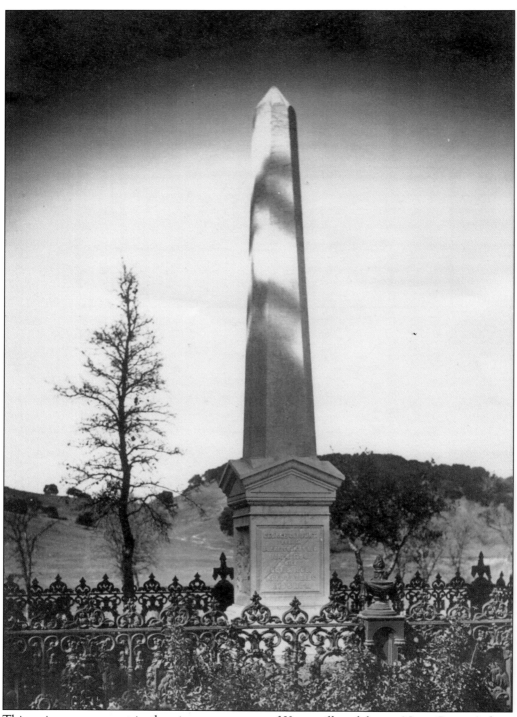

This unique monument in the pioneer cemetery of Yountville celebrates Napa County's foremost pioneer, George Yount (pronounced junt).

IMAGES
of America

NAPA

AN ARCHITECTURAL WALKING TOUR

For "Maddy" and Ryan
Wonderful seeing you
and catching up.

Anthony Raymond Kilgallin

Cheers, Tony

ARCADIA
PUBLISHING

Published by Arcadia Publishing
Charleston, South Carolina

Printed in the United States of America

Library of Congress Catalog Card Number: 2001090992

For all general information contact Arcadia Publishing at:
Telephone 843-853-2070
Fax 843-853-0044
E-Mail sales@arcadiapublishing.com
For customer service and orders:
Toll-Free 1-888-313-2665

Visit us on the Internet at www.arcadiapublishing.com

This book is dedicated to the best director of my world, my ever patient wife, Patricia.

CONTENTS

ACKNOWLEDGMENTS

Nominated for **BEST SUPPORTING CAST** in Napa County are the following stars of the NAPA COUNTY HISTORICAL SOCIETY and NAPA COUNTY LANDMARKS:

Pat Botts
Byron Brady
Nancy Brennan
Elizabeth Brereton
Diane Christman
Dawne Dickenson
Howard Dickenson
Georgina Dillon
Jess Doud
Leslie Erickson
Leslie Friedman
Carl Fry
Christine Fry
John Futini
Donna German
John Graham
Noreen Hanna
Robin Hart
Cindy Heitzman

Helen Hinde
Margaret Clark Hoover
Jane and Kenneth Imrie
Tammy Jeschke
Lorraine Jones
Lorrain Kongsgaard
Tom Kongsgaard
Kathy Kernberger
Betsy Kilburn
Pat Lecair
Alvin Marlow
Henry Mauldin
Abbie Meaker
Bette Morgan
Judith Munns
Jim Nord
Robert Northrop
Madeline Bartlow Ontis
Gloria Palmer

Frederick Pond
Carole Perkins Poole
Toni Porterfield
Bea Purdy
W. Harold Reames
Maybelle Rodin
Nancy Sange
Cecelia Elkington Setty
Dorothy and Ned Soderholm
Edna Steele
Floyd Stone
Alice Taplin
Dorothy Throne
John Wichels
Ted Wigger
Avis Willis
Rose Willis
Joseph Willis

BEST SUPPORTING ACTOR: Bryan Payne

BEST ACTRESSES: Diane Ballard and Sharon Lampton

BEST ACTOR: Leaf Christopher Kelly

INTRODUCTION

The best introduction to Napa County is a personal visit. The sooner the better, as America's greatest philosopher and essayist of the 19th century learned 130 years ago. Ralph Waldo Emerson (1803–1882) visited Calistoga in 1871. The following is extracted from a letter to his wife.

Dear Lidian,

We live today and every day in the loveliest climate. Calistoga is a village of sulphur springs, with baths to swim in, and healing waters to drink. The roads and the points of attraction are Nature's chiefest brags. And if we were all young—as some of us are not—we might each of us claim his quarter-section of the Government, and plant grapes and oranges, and never come back to your east winds and cold summers—only remembering to send home a few tickets of the Pacific Railroad to one or two or three pale natives of the Massachusetts Bay, and half-tickets to as many minors. Its immense prospective advantages only now beginning to be opened to men's eyes by the new Railroad are its nearness to Asia and South America. With this assured future in American hands, Chicago and St. Louis are toys to it. I should think no young man would come back from it.

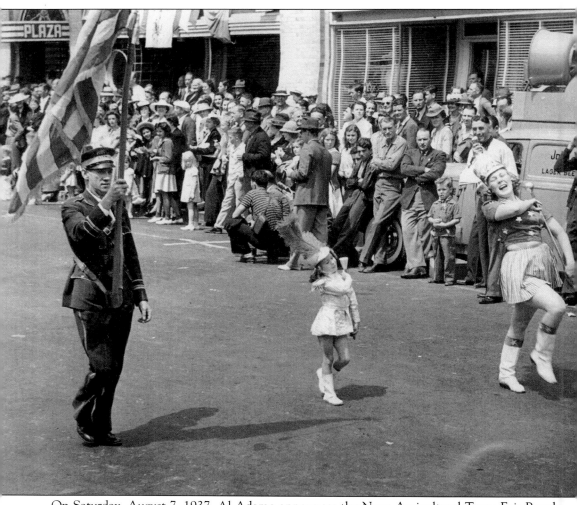

On Saturday, August 7, 1937, Al Adamo announces the Napa Agricultural Town Fair Parade on Brown Street.

One

NAPA CITY

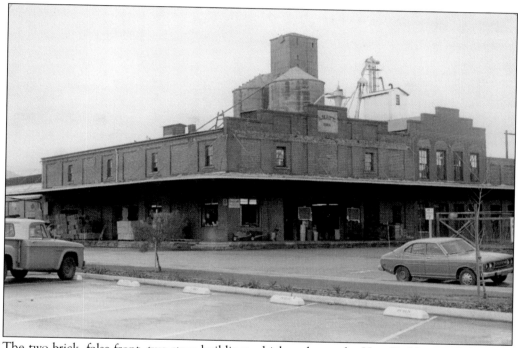

The two brick, false front, two-story buildings which make up the Hatt Building and the brick warehouse across the street from it are the last of the large 19th century brick industrial buildings which once clustered along the commercial wharves at the foot of Main Street. They are remarkably unaltered in their original design details with original post and interior construction, cast iron shutters, stepped gable cornice, and stone landing remaining. The first Hatt Building was constructed in 1884 of brick made from Napa River clay and has a 65-foot frontage on Main and 105-foot frontage on Fifth Street. The lower floor was used for distributing hay, grains, and coal; the upper floor with an unusual hardwood floor was used for dances, a roller skating rink, and a basketball court in later years. Note the plaque "A Hatt–1884" for Capt. Albert Hatt, owner of the building. The building adjoining it to the south was built c. 1886–87 of brick from the San Quentin area. The second floor has pressed-iron wainscoting added in 1901. Note the grain milling equipment. Captain Hatt was a leading milling and warehouse operator as well as owner of a boat plying the important Napa River trade.

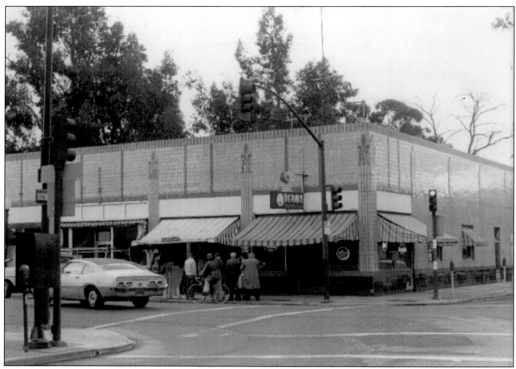

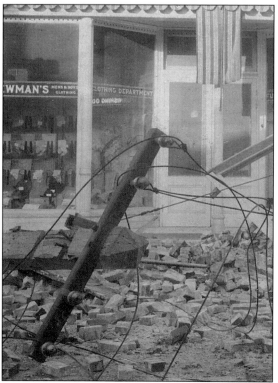

The Art Deco style of the 1930s is rarely seen in Napa County and its characteristic glazed tile facade is found only in the Oberon Bar in Napa at 902–912 Main Street. The most significant and unusual feature of the Oberon Bar is the sophisticated treatment of the stylized Ionic columns in tile with their "capitals" in polychromatic tiles picking up the floral patterns common to Art Deco. Unaltered in design, the Oberon Bar possesses on a simple scale the major features of the style: an angular appearance with a vertical emphasis in the stylized columns in relief; hard-edged low-relief patterns around the door and window openings; ornamental detailing in contrasting tile along the sidewalk and roof edges; and zigzag decorative banding above the first floor storefronts.

On April 18, 1906, the San Francisco Earthquake reached as far as this store at Main and Second in Napa.

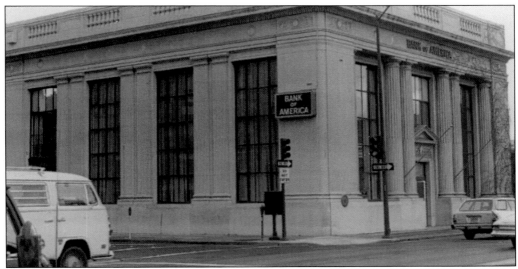

The Bank of Napa-Bank of America building at 903 Main is the only example in Napa of the Beaux-Arts Classicism style of the late-19th and early-20th centuries, which we have come to identify with government and commerce. This area bounded by Main, Brown, First, and Third has been historically the banking center of Napa, with five banks once located here. The bank building, erected as the Bank of Napa in 1923, is a two-story structure of reinforced concrete. Six massive Doric columns on the Main Street facade support the ornate cornice with its dentils, frieze, and parapet.

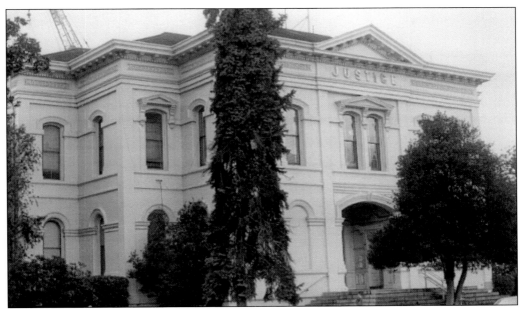

Luther M. Turton designed the Winship building (1888), long a prominent visual landmark at the intersection of 19th-century Napa's busiest commercial streets, in conjunction with the adjoining Semorile Building. Both buildings, in the commercial Italianate design, are significant in presenting a coherent 19th-century street facade, one of only two locations in Napa's commercial district which recall the 19th-century city.

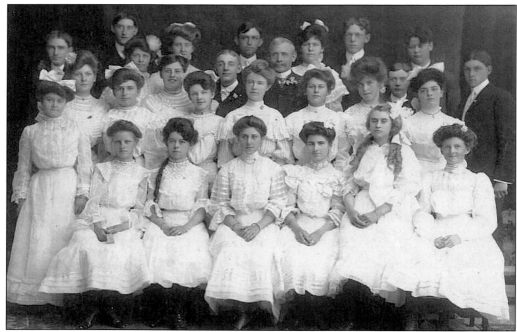

On Tuesday, May 26, 1904, graduation exercises for Napa Central School are held at 8 p.m. sharp at the Napa Opera House. The word "opera" was a $10 word for vaudeville.

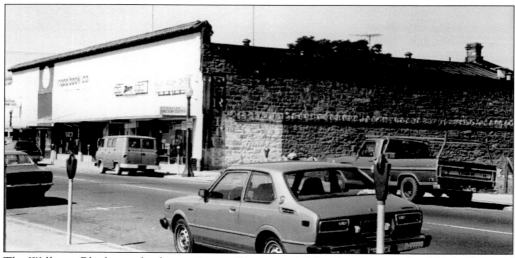

The Williams Block was the first major retail commercial development north of the bridge over Napa Creek on Main Street in 1886. It was expected to draw business northward along Main Street from its core at First and Main. Subsequently, brick and stone would replace many of the early frame false-fronts prevalent in the 1870s and 1880s in the downtown district. The three-section, one-story Williams Block of native stone marks this transition to stone and stands as one of the earliest remaining commercial blocks in Napa. The heir of George Williams contracted with architects Wright and Saunders to design the building. The unadorned commercial style reflects the craftsmanship in stone of Napa's 19th-century stonemasons. It was lit with skylights and encircled with galleries inside.

Known since the 1920s as the Sam Kee Laundry, the Pfeiffer/Barth Brewery is the oldest stone commercial structure remaining in Napa. Its simple commercial Italianate false-front style is representative of the earliest commercial buildings in Napa, which were more commonly built of wood. The two-story rectangular building is of native cut sand stone. The main facade has a symmetrical arrangement of windows and a central door.

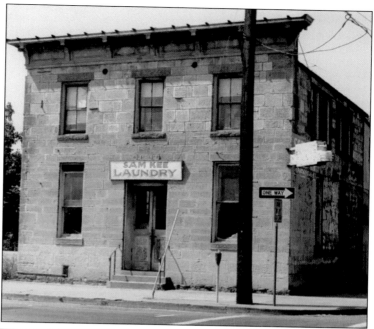

Main Street north of the commercial district became a residential district for many of the downtown merchants at the turn of the century. The Brown House (1891), 1543 Main, is a very fine example of a transitional house combining elements of the Queen Anne, Bungalow, and Colonial Revival styles. It was occupied by J.L. Brown, president of Nickels and Brown Bros., a meat market a few blocks south on Main Street. The sweeping roof has projecting attic gables supported by Colonial Revival columns, recessed porches with turned balusters, and shed dormers. Note the Palladian window treatment in the front attic gable. To one corner is a polygonal bay giving the appearance of a tower, a carry-over from the Queen Anne style. The curving veranda in front has a triangular pedimented portico supported by Doric columns. Note the variation in texture from narrow horizontal siding on the first level to shingles on the second.

The rhythmic placement of the arched windows of the old Napa Steam Laundry (1900) at 1600–1616 Main Street in the Romanesque Revival style contributes to the significant impact of this turn-of-the-century industrial building on the streetscape at the corner of Main and Vallejo Streets, just north of Napa's commercial district. The Romanesque Revival style, most often associated with churches and government buildings, is emphasized here in the semicircular arched windows with their corbelled hoodmolds.

The transitional bungalow with a corner bay is seen throughout Napa in the neighborhoods developing at the turn-of-the-century. The De Curtin House (1900) at 1631 Main Street has an unusually fine corner bay with unique window moldings. William De Curtin, president of the California Brewing Association on Soscol Avenue, manufacturers of Golden Ribbon Beer, lived here in the early 1900s. The hip roof bungalow sits on a raised foundation. It has the characteristic side front porch and a square corner bay. A modillioned cornice continues around the house.

The Jillson House (1890) at 1645 Main Street, a Stick style residence, reflects the wealth of its early owner, C.B. Jillson, whose profession was listed only as "capitalist" in the early 1900s. Two story square bays in front and to the sides carrying decorative gables with carved sunburst motifs are characteristic of the Eastlake influence of the 1880s. The low hip roof has a bracketed cornice and stick work frieze. Plain stick work molding surrounds the one-over-one sash windows. Note particularly the fine gabled portico with decorative sunbursts and delicately turned porch columns. Double doors with a transom form the main entrance. The raised foundation has wood siding, which has been rusticated to appear as stone. The iron fence surrounding the yard is noteworthy for although many of the concrete curbs are still to be seen, the iron fences have disappeared from most residences.

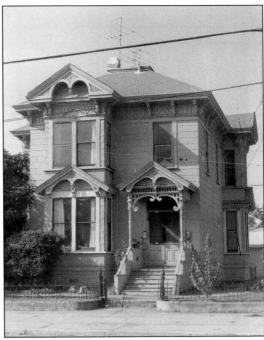

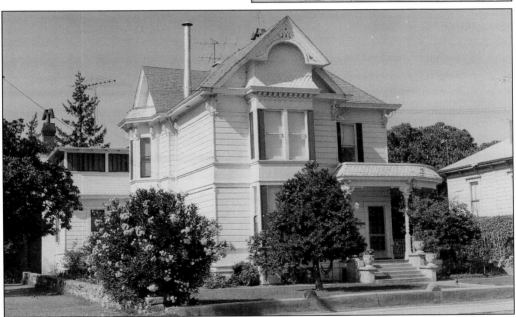

In 1889 Dr. Hennessey, the county physician, had his residence built at 1727 Main, a few blocks north of his offices in the Winship Building. His Queen Anne style house constructed by local builder M.E. Johnson is one of only a few of the large 19th century houses remaining on north Main Street. The Stick and Eastlake influences are evident in the two-story front bay with its bracketed and shingled cornice with decorative projecting gable and pierced bargeboard. A side-slanted bay has slender colonettes and an elaborate-scrolled and pierced bracketed cornice. Siding is shiplap with wood concealing the stone foundation.

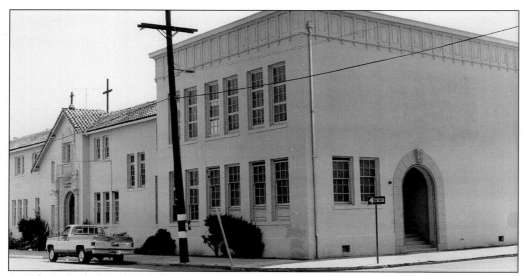

St. John's Catholic Church (1927) at 983 Napa Street has been a focal point of this neighborhood since the late 1850s when the first church was built. In about 1912 St. John's School was organized and c. 1927 the school moved into this Spanish Colonial Revival structure. The Spanish Colonial Revival influence is most pronounced in the molded cornice of the two-story building and in the entryway on Napa Street. Note the spiraled pilasters flanking the semicircular arched doorway, the balcony above the door, and the curvilinear cornice window head of the second-story window.

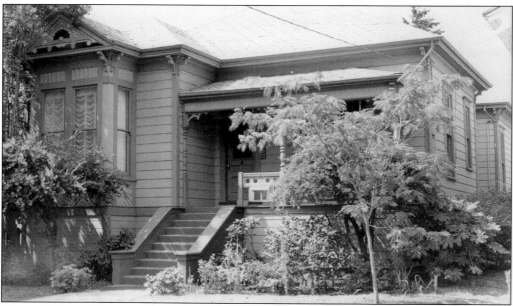

Many of the residences on north Main Street built for merchants whose shops were in the commercial district to the south were on the modest scale of this one-story cottage (1890) at 2041 Main Street on a raised foundation with a Stick style front bay window. Note the Eastlake influence in the projecting gable with its decorative stick work, a feature often seen in much larger houses.

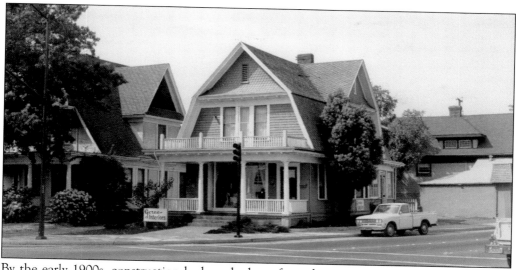

By the early 1900s, construction had reached out from the commercial downtown along the residential length of Main Street to Lincoln Avenue which formed the northern boundary of the city. Clustered at Lincoln and Main are several versions of the popular Colonial Revival style. This gambrel-roofed house (1910) at 2151 Main with its shingle detailing is seen in scattered neighborhoods of Napa, which were developing c. 1910. Note the combination of surface textures common to this transitional period as seen in the narrow horizontal siding of the first floor, shingle siding of the second, and decorative fish scale shingles in the gables.

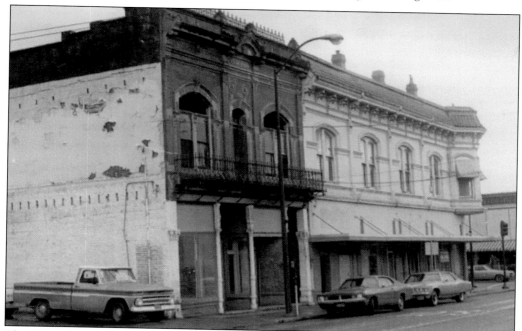

The Semorile Building (1888) at 975 First Street is an outstanding example of Victorian commercial architecture and one of the few remaining buildings of its period in Napa. It was one of the first commercial commissions for Luther M. Turton, who was to become Napa's most prominent architect in the late-19th and early-20th centuries.

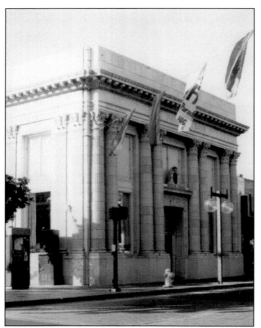

The First National Bank building (1916–17) at 1026 First Street, a major bank in Napa's historic banking district bounded by Main, Brown, First, and Third, is distinctive among the few Neo-Classical structures in Napa County in that it shows the Beaux-Arts Classicism design theme in its paired colossal columns on Main Street. Of brick, with a smooth terra cotta surface, the facade is distinguished by a plain frieze with an elaborate cornice exhibiting dentil work and egg and dart molding; a fine doorway with a dentiled pediment and a large cameo terra cotta sculpture; and four pairs of Corinthian columns. Twelve Corinthian pilasters dominate the west wall and the dentiled cornice continues on the west wall as well. North and east walls intended to be flush against other buildings are plain brick. Although the exterior is essentially unaltered, the interior has undergone major remodeling.

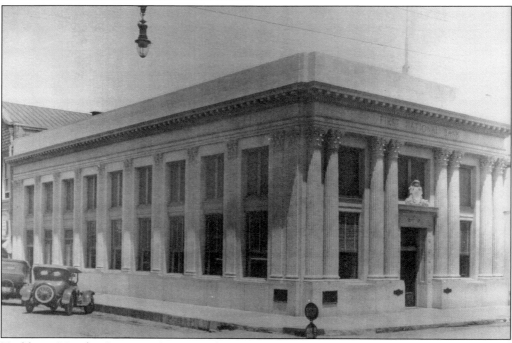

Visible on Monday, January 15, 1917, is the First National Bank, currently the John Whitridge III Community Preservation Center, and headquarters for Napa County Landmarks, whose motto is, "Window to the past, foundation of the future." Its mission statement promotes preservation and community appreciation of irreplaceable historic buildings and sites in Napa County; provides community educational programs, public policy advocacy, and direct technical services; and protects a living record of the past for future generations.

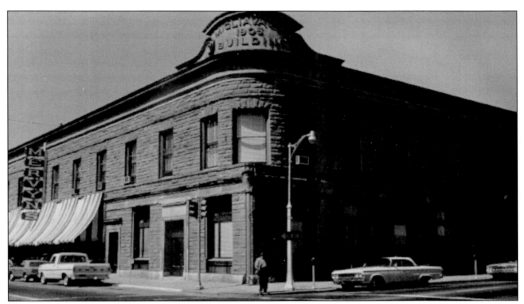

The Migliavacca Building at the northwest corner of First and Brown was the largest commercial stone building in the City of Napa and possibly in the county outside of Greystone Winery. Architect Luther M. Turton and builder J.B. Newman were both significant in Napa County building history. Owner G. Migliavacca was very prominent as a businessman, active in the wine industry, and in the development of the Bank of Italy, later Bank of America. The building was razed as part of downtown redevelopment in 1973. It was a two-story building with a basement of cut stone. A shield was attached at the top of the southeast corner with the legend "Migliavacca Building 1905."

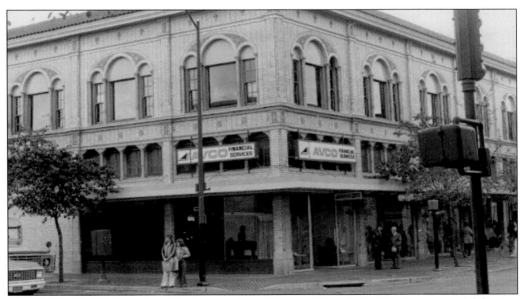

The Gordon Building, at the major intersection of First and Coombs in Napa's commercial district, carries a highly unusual decorative commercial facade. The Spanish Colonial Revival influence is most pronounced in this 1920s facade, which also carries a suggestion of the Spanish Renaissance.

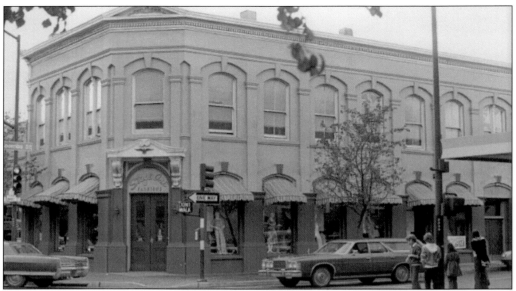

Although built in 1905, the Napa Register Building is one of the few remaining examples of 19th-century architecture in Napa's downtown, and is the former home of *The Napa Register*, Napa's oldest paper in continuous publication. A two-story brick structure with cement facing carved to appear as stone, the Napa Register Building is on the corner of First and Coombs, central now to the business district though on the outskirts in 1905. Essentially unaltered in design, the commercial facade has ten arched windows on each level. The contrast of the recessed segmental arch trim of the upper windows with their keystones and the protruding arch trim of the lower windows plays on light and shadow, a common Victorian theme.

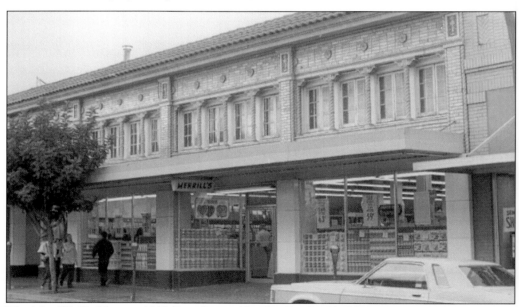

The Merrill's Building at 1212 First Street, like the Gordon Building at 1130 First Street, presents a decorative facade of the 1920s in which the Spanish Colonial Revival influence is most evident in the commercial facade.

The Goodman Library at 1219 First Street is unique in several respects. It is one of the few examples in Napa County of the Richardsonian Romanesque style combined with new-classical Beaux-Arts elements; as such it represents a move away from the Victorian decorative tradition of 19th-century Napa City. It also marks a transition in the work of prominent local architect, Luther M. Turton, who did many of the commercial buildings, churches, and Queen Anne style homes in Napa. Of native stone, the Goodman Library has retained its integrity of design in every detail. As one of the few remaining stone buildings in Napa City, it remains a focal point in the center of the central business district. George Goodman gave the city the parcel of land and the building to be used as a "free public library." The Goodman Library and Tea Room formally opened in 1902 and remained in continuous use until 1974 when the new city/county library opened.

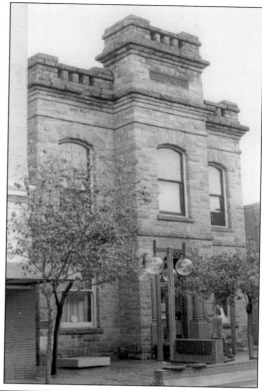

On Thursday, May 2, 1901, the cornerstone of the Goodman Library is laid. The tripod is visible in the center of the picture.

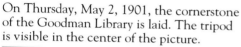

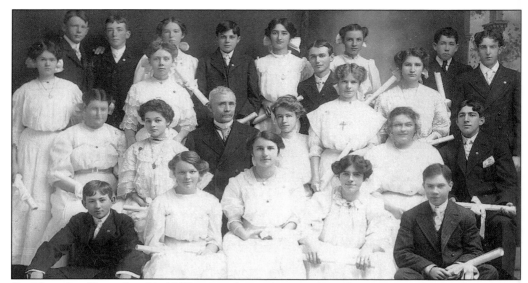

On Thursday, December 19, 1907 we see the graduating class of Napa Central School, Principal John L. Shearer and teacher Kate Mitchell presiding. City Hall stands today on the site of Napa Central School.

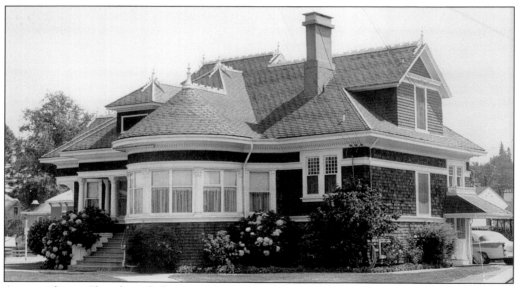

A magnificent Shingle style house with a strong Queen Anne influence, the Hunter-Prouty House (1903) at 1801 First Street is an unaltered design of local architect William Corlett. The multi-gabled roof with its wood cresting and rounded bay window topped with a conical roof are synonymous with the Queen Anne style. The strong horizontal lines of the house defined in the dentiled cornice, window detailing, and belt courses and the shingled wall surface are of the Shingle style. Note particularly the Colonial Revival columns with Ionic capitals supporting the porch overhang and the pilasters with Ionic capitals of the rounded bay window. The windows are one-over-one sash with several windows having a multi-light upper sash. William Hunter, in real estate, had the house built as his residence in 1903. It was later the home of A.G. Prouty, prominent Napa jeweler.

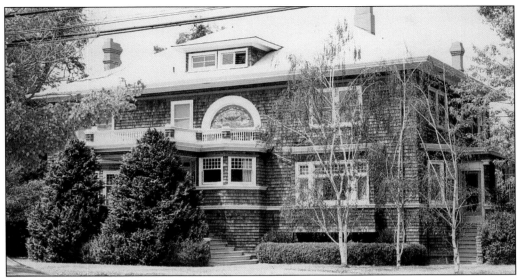

The Kahn-Voorhees House (1905) at 1910 First Street is an excellent example of the work of local architect Turton in the Colonial Revival and Shingle styles popular in Napa c. 1900–1910. The Shingle style is illustrated in the uniform covering of shingles and simple eave treatment; the Colonial Revival reflects the Georgian period with its hip roof, rectangular shape, and symmetrical composition. Note the variation in bay window treatments in the facade, the stained glass half-round window, the entrance portico, the cut stone foundation, and the windows with their 18 lights over 1. Dr. Adolph Kahn, a prominent physician and surgeon in Napa, also served as county physician and city councilman. He commissioned Turton to design this house as his residence. In later years, A.L. Voorhees, well-known men's clothing merchant in Napa, lived here. The original barn-carriage house remains at the rear of the property and the stone carriage step is on Warren Street.

The George H. Francis House (1905) at 1926 First Street is a popular rendition of the Shingle style, which was at its peak in Napa in the early 1900s. Luther M. Turton designed the house for George M. Francis, owner and editor of *The Napa Register*, who gave it to his son, George H. Francis. The twin dormers in the steeply pitched roof and shingled gable end facing the street are characteristic of this vernacular rendition influenced by the earlier designs of Frank Lloyd Wright in Oak Park, Illinois.

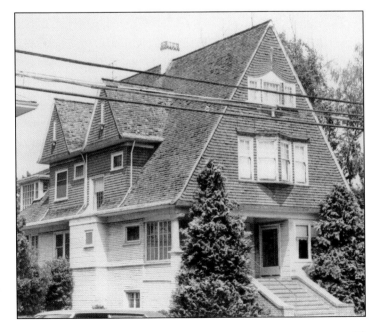

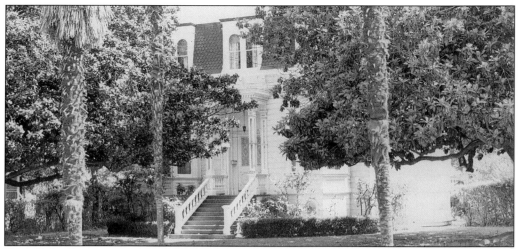

One of the finest examples of the Second Empire style in Napa is the William Smith House (1875) at 1929 First Street. It carries the hallmark of the style with a high concave mansard roof with dormer windows. The two-story house is of redwood with shiplap siding; octagon shingles cover the mansard roof and the paired arched windows in the dormers are consistent with this formal style. The paneled frieze distinguishes the main cornice of the house and large pierced brackets interspaced with smaller brackets. Note particularly the slanted bay windows flanking the portico over the recessed and paneled entryway.

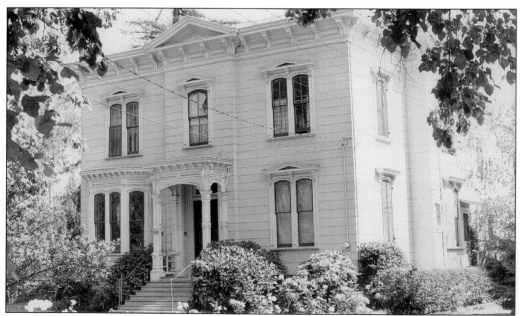

Napa pioneer J.S. Trubody had his residence built in West Napa (1875) at 2021 First Street in the Italianate Villa style, though the characteristic square tower is only hinted in the slightly projecting central facade with its triangular pediment. The Trubody House has survived remarkably unaltered in its ornamentation. J.S. Trubody, born in England, arrived in Philadelphia in 1830 and in Napa c. 1850. He originally settled north of Napa and raised the first commercially grown vegetables in Napa County.

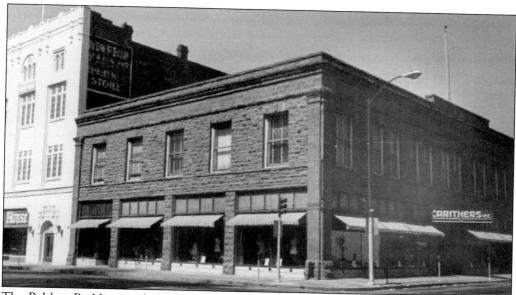

The Behlow Building at the corner of Second and Brown was one of the largest commercial stores in Napa City. The original first floor tenants were Thompson, Beard, and Sons, who in 1900 were reported to be the largest department store in northern California. The architect was Turton and the builder Newman. The two-story building, with a basement, was of hand-cut sandstone and was built in 1900–1901. The stone was locally quarried. After a fire in the 1930s, the south wall was modified in keeping with the original design.

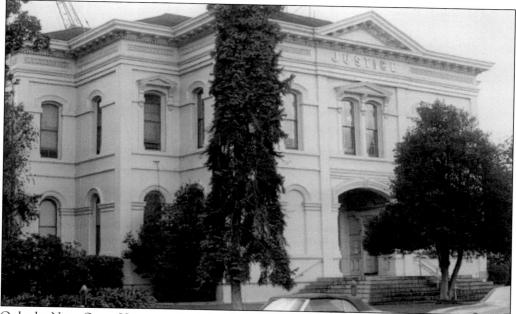

Only the Napa Opera House matched the Napa County Court House of 1878 at Brown and Second, Napa County's third court house, in the sophistication of its Italianate facade at the time. Both were executed by the Newsom Brothers, the foremost Victorian architects in California of the period, and their local representative, Ira Gilchrist, owner of the Napa Planing Mill.

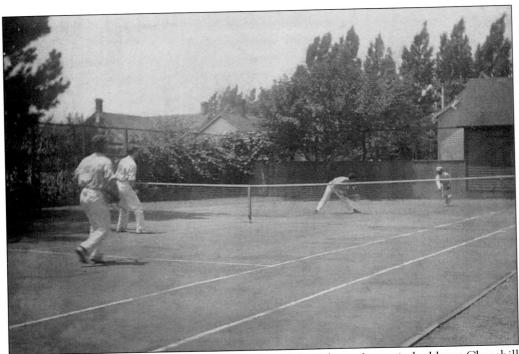

Enjoying Independence Day in Napa on Saturday 1896, with men's tennis doubles at Churchill Manor, 485 Brown Street, are from left to right: Leslie Allen, George Francis, W. James, and Ed Churchill.

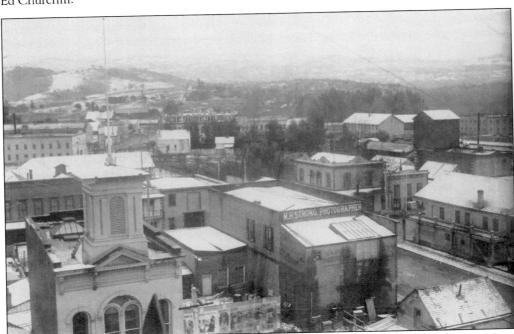

On Tuesday, March 3, 1896, we look southeast from the Courthouse Bell Tower upon a rare Napa snow scene.

This is the Alert Hose Team on May 12, 1888, in front of the Napa Court House. From left to right are: John Even, W.J. Dinwoodey, Al Lockard, Gus Stoddard, George Woelffel, Pete Jensen, John Brodt, Lou Fowler, James Sampson, Paul Michelson, Adolfe Flamant, Laurence Mackin, and George Breitenbach.

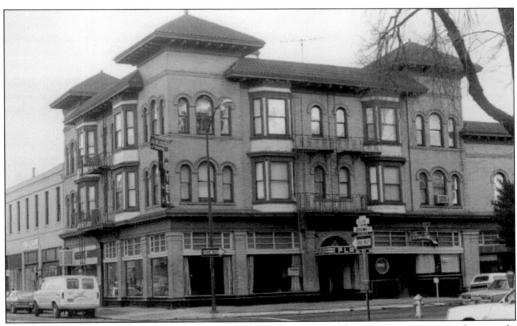

The Alexandria Hotel (1910) at 840–844 Brown Street, now the Plaza, is an unusual example of the Italian Villa style applied to a commercial building in the first decade of the 20th century. The three-story brick building is defined by three square towers, projecting eaves supported by brackets, semi-circular arched windows, and bay windows, all characteristic of the Villa style. The second and third levels, which are most architecturally significant, have retained their original design. Note particularly the Palladian windows in the towers. The first floor facade reflects the changes of the 1930s with the streamlined glazed tile facade found on several buildings in this downtown area.

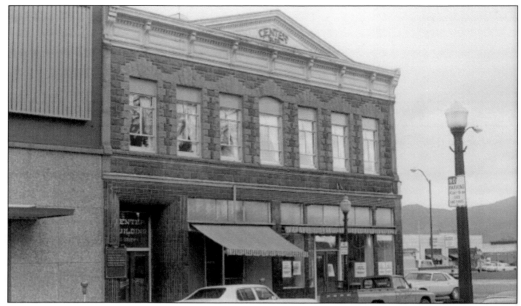

The two-story rectangular building of rough cut native stone and brick at 816 Brown has a finished facade of brown and gray stone. The second story is relatively unaltered. The decorative stone trim of the windows is a major feature with quoins and radiating stones at the window heads in a contrasting color accenting the windows. Note the rectangular windows are in sets of three separated by a central window with a segmental arch, a formal arrangement of the Renaissance Revival. A cornice with paneled frieze, dentil trim, and brackets supports a triangular pediment. The name "F. Martin" has been replaced by "Center Bldg." F. Martin was a prominent liquor dealer in Napa. City Hall was adjacent to the building on the north and the County Courthouse directly across the street.

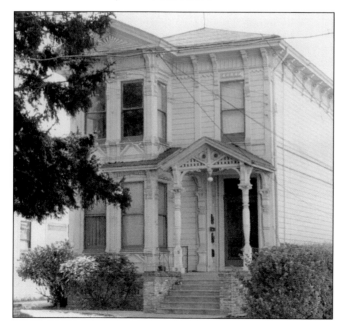

The Capt. Pinkham House (1880) at 529–531 Brown is one of several houses in the Brown and Division Streets neighborhood originally occupied by families active in important Napa River traffic in the 19th century. Captain Pinkham, operator of the steamboat landing wharf and owner of one or more of the paddlewheel steamers over the years, lived in this Stick style residence. The Pinkham House has a two-story bay window in front and to the south side. Note the triangular pediment with a sunburst motif and the applied stick work around the one-over-one sash windows and along the frieze. Siding is of shiplap.

The Wulff House at 549 Brown, a two-story Italianate residence, faces the Napa River today as it did when Capt. N.H. Wulff, owner of the paddle wheel steamer *Zinfandel*, lived there. The eaves, supported by elaborate brackets against a paneled frieze and the fine example of an entrance porch with its columns and Corinthian capitals, transomed doorway, and two-story five-bay window distinguish the house. Capt. Wulff could keep an eye on his steamer from his house as the *Zinfandel* wharf, immediately south of steamboat landing, was practically opposite the house.

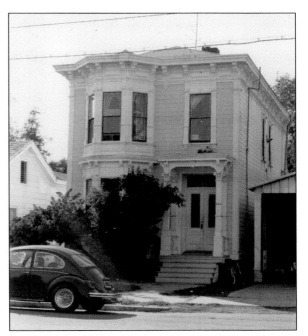

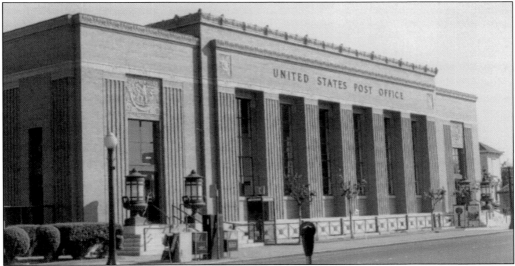

The Franklin Station Post Office, 1351 Second Street, Napa, is of a style familiar throughout the country in post offices constructed during the 1930s. In the Art Deco style, often called WPA Moderne, the Franklin Station is the most prominent example of its style in Napa and is a reminder of the many federal buildings undertaken by the Roosevelt Administration to provide employment during the Depression. Designed by local architect William H. Corlett, the building is of brick and carries a cornice with an ornamental terra cotta frieze of shields and rams heads. Grooved pilasters set apart the massive vertical windows; large eagles are sculpted into the frieze above the north facing doors. The monumental nature of government buildings of the period is reinforced in the interior with marble wainscoting, an elaborate Art Nouveau frieze, sculptured eagles, and star ceiling designs. The interior is remarkably unaltered following a 1965 renovation, which added additional offices in the basement and an exterior ramp.

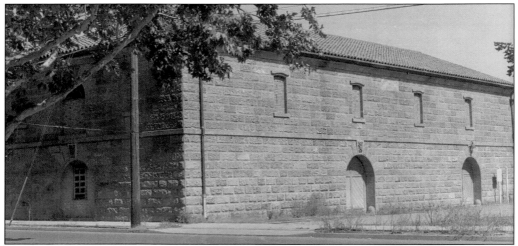

The Lisbon Winery at 1720 Brown Street is the only winery in Napa City today virtually in-
tact in its original design features. It is reminiscent of the 1880s when Napa County was at the
height of its early viticultural period and several wineries were operating in Napa City. The
two-story rectangular winery with its hip roof terminating in a gable end on the eastern side was
constructed of native stone quarried east of the city. It was built adjacent to an earlier sherry cel-
lar, one of the largest in California (in 1884), which was operated by Joseph A. Mateus. Mateus,
born in Lisbon, Portugal, began construction of the Lisbon Winery in 1880; it was completed in
1884. Mateus was also an accomplished stonemason and did the decorative arches of the door-
ways himself. Note the arch treatments of the doorways stepped radiating stone with a center
keystone with a decorative motif. The rear of the building is of field stone construction and only
two brick walls remain of the sherry cellar. Today it houses the Jarvis Conservatory, ironically
dedicated to the Zarzuela of Iberia, the birthplace of Mateus.

This is the Napa City Fire House on the north side of Second Street between Randolph and
Coombs. From left to right are: Harry Bruton, Charlie Roberts, Jeff Smelzer, Tom Lane, Henry
Frisch, Sug Olmstead, and Henry Prugiler (sp).

This is the interior of the Napa Fire House Auxiliary next to the fire house.

This is the last picture of the Napa City Hook and Ladder taken at a reunion at Theo Gier's, Mont La Salle, on Sunday, May 5, 1918. From 1886–1907, the Napa Hook and Ladder kept its membership to 40 men. Napa had no fire chief until 1907 and each company of volunteers selected their own foremen, commencing with its initial organization on October 10, 1873.

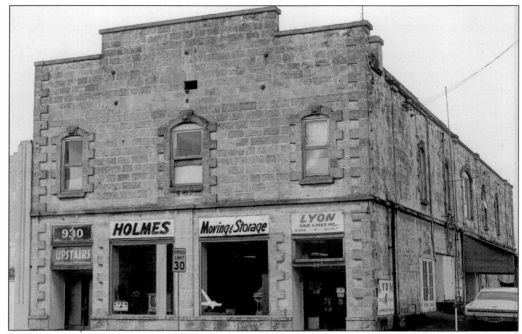

The Borreo Building (1887) at 920 Third Street is the only stone commercial building remaining in this once thriving commercial area of Napa. Situated near the Napa River, it was easily accessible to the wharf, railroad, and old depot. A two-story building of native stone quarried in the Soda Canyon area, it has a simple facade of coursed cut stone accented by the raised stonework of the window, door, and corner trim. Originally, all openings had a segmental arch with a keystone. In 1908 the Borreo family sold the building, and it then housed the grain and feed department of Thompson Beard and Sons, a forerunner of Carithers Department Store.

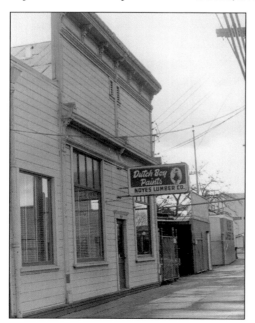

The Noyes-Newman building (1890) at 929 Third Street is one of the very few wood, false front buildings remaining in Napa County and is perhaps the finest in decorative detail. Once so characteristic of the 19th and early-20th century streetscape in Napa, the commercial wood false fronts gave way to stone and brick on the main commercial streets but were retained into the early decades of the 20th century for the simpler retail stores and shops. This one and one-half-story frame building with a gable roof gives the appearance of a two-story building. The mansard cap of the cornice, taken from the Second Empire style currently in vogue, was in keeping with the Palace Hotel next door. J.B. Newman was a well-known contractor in stone responsible for several of the stone bridges in Napa County. The Noyes Lumber Company, originally located on Main Street, moved to the site in the early 1900s.

An exceptional example of late Victorian Gothic church architecture is the original wood frame, 1874 First Presbyterian Church at 1333 Third Street, with its 1890 chapel wing to the rear. It has survived with only minor changes. Consistent with the Victorian Gothic style, the gable, eave, and entryway trim is massive and defined in a contrasting color and the traditional Gothic pointed-arch windows and doors are used. Note the unusual wood decorative trim of the third level of the tower. In 1911, the original gas fixtures were converted to electricity and are in use today. The Rev. J.C. Herron from Philadelphia established the First Presbyterian Church congregation in 1853–54. Nathan Coombs donated the site and the first church was completed in 1857. It was moved from the site when the present church was constructed. The interior was altered slightly when the pipe organ was moved. The organ came from San Francisco in 1874 via river steamer to Napa. The church is a dominant landmark in Napa and marks the transition from commercial to residential neighborhoods. It is on the National Register of Historic Places, and is a state landmark.

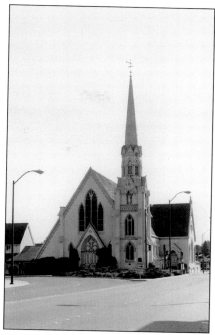

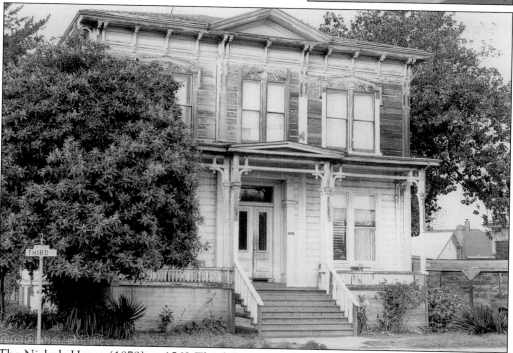

The Nichols House (1879) at 1562 Third Street was designed by Napa architect and builder, Ira Gilchrist, in the Italianate style. Gilchrist, the local representative in Napa of the Newsom Brothers, California's foremost Victorian architects, was also involved in the design of the County Courthouse and the Napa Opera House. The Italianate features of the late 1870s are evident in all three buildings.

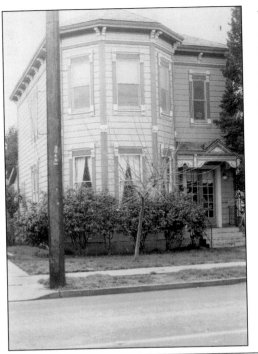

The Levinson house (1886) at 2265 Third Street, in the 1880s Stick style, is an unusual structure in this neighborhood of transitional homes of the early 20th century and later. It was moved from its original lot of the northwest corner of First and Franklin when the area became heavily commercial in 1954. The builder, Thomas Parkinson, a Napa millwright specializing in redwood milling and molding, embellished the narrow, two-story house with elaborate millwork. The projecting two-story bay and the cornice of the porch roof are dominant features. Note the decorative scrolled and pierced brackets supporting the roof cornice and the pierced brackets applied to the corners of the windows supporting the window hoods and decorated lugsills. The squeezed pediment of the porch cornice, the applied decorative panel, the dentiled frieze, and pierced corner brackets exhibit the millwright's art. Joseph Levinson, who established Napa's first drugstore that still carries the name, rented the house until 1925.

The stagecoach driver on May 5, 1894 is 25-year-old John Brandlin. This stage ran regular mail and passenger service from Napa to Napa Soda Springs. The horses are Duke, King, Prince, and Pedro. The photographer was M.H. Strong.

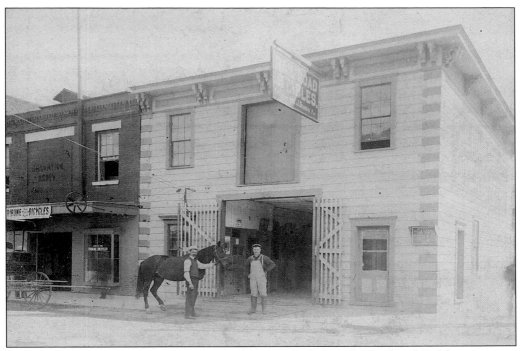

This Livery Stable is at Third and Soscol. These are the J. Brandlin Railroad Stables.

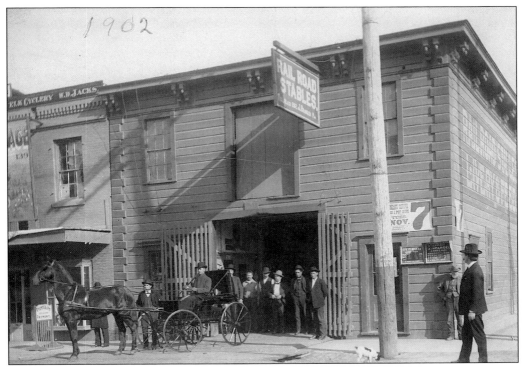

The Railroad Stables Livery and Feed is shown in 1902.

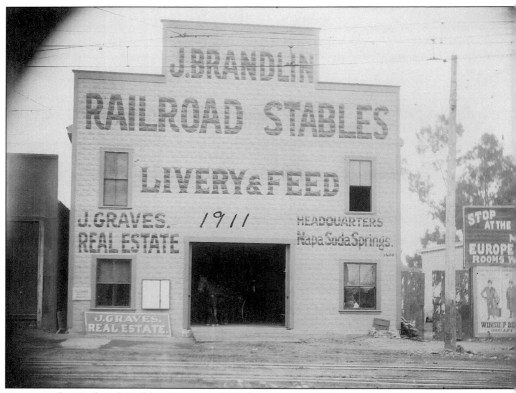

Here are the Railroad Stables Livery and Feed as seen in 1911.

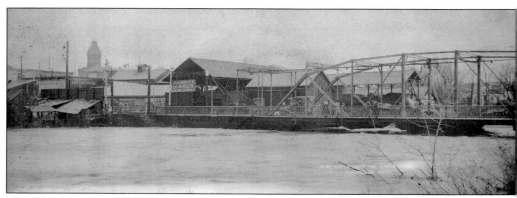

This Third Street steel drawbridge was built in 1892. This picture shows a flood in the winter of 1907. In 1932, the present concrete bridge was built.

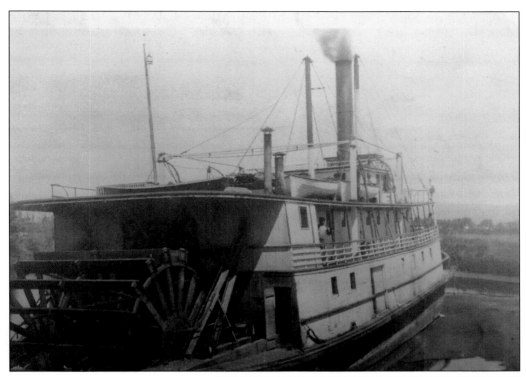

This is a stern view of the steamer Zinfandel brought to Napa in June 1889 by Captain Wulff. This is one of the last passenger boats that ran between Napa and San Francisco three times a week. Monday, Wednesday, and Friday were the days of departure from Napa. Sunday excursions were extremely popular because the Zinfandel left Napa early and returned from San Francisco about 9 p.m. Its dimensions were 125 feet by 29.5 feet by 7 feet, and it weighed 329.15 net tons.

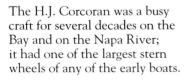

The H.J. Corcoran was a busy craft for several decades on the Bay and on the Napa River; it had one of the largest stern wheels of any of the early boats.

South Franklin Street, only a couple of blocks from the Sawyer Tannery on Coombs Street was a neighborhood of workingmen, tanners, paperhangers, stevedores, and river men. At the turn of the century, C. Petersen, stevedore, and J.L. McMellon, paperhanger, lived in this two-story Italianate house (1875) with their families. The house is one of only a few reflecting the 19th-century character of the early neighborhood. The house carries the characteristic features of the style: symmetrical facade, rectangular plan with a low hip roof, and elaborate bracketed cornice. Note the pierced and scrolled brackets and paneled frieze. Siding is shiplap. Windows are one-over-one sash with squeezed pediments and decorative sawn lugsills. The cornice brackets, window moldings, and delicately turned columns are a fine decorative influence in an otherwise modest house.

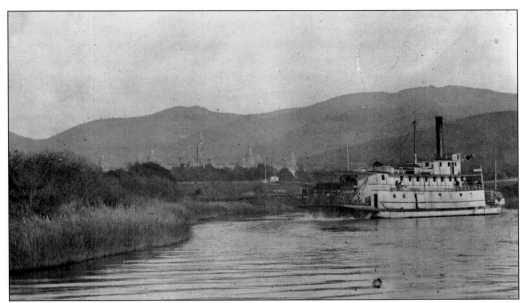

This is the Zinfandel with the Napa State Hospital in the background.

The Franklin Primary School/Napa Women's Club at 218 Franklin Street appeared on 1891 maps as a one-room school with a large shed attached. At that time it was the Franklin Public School and only two blocks away was the Oak Mound School for boys, a private school. Soon after 1901 the school was enlarged to its present size and appearance with a central hip roofed core flanked by two hip roofed wings. The window moldings are of particular interest with a decorative eared lintel with a pediment and four-over-four sash windows. The one story building has shiplap siding with a central recessed entryway. Note the gable-roofed dormer with Palladian style vents over the entryway.

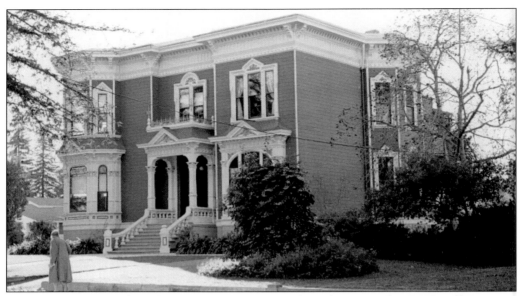

The Holden Mansion (1886), a two-story mansion in the Italianate Style, is an excellent example of renovation and conversion of a large residence to multiple residential, used while maintaining the facade. The interior, though now divided into apartments, retains its original oak staircase, doors, and other woodwork. The original owner of the mansion, Samuel E. Holden, an attorney from New Hampshire, arrived in Napa in 1875. He eventually became president of the Sawyer Tanning Company, a major economic force in Napa, and of the Napa Woolen Mills, as well as president of the Board of Directors of the Napa Collegiate Institute.

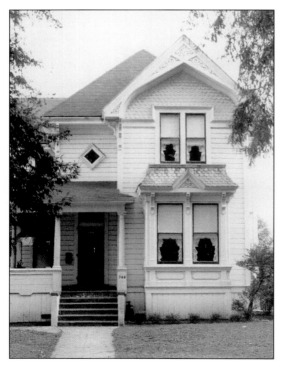

Speculative land development was practiced in the 19th century in Napa as seen on Franklin Street between Laurel and Pine. The Keig House is representative of four once identical Queen Anne houses built on speculation by a contractor: 356, 366, 376, and 386 Franklin. As a group the houses have a significant impact in retaining the character of the original residential Victorian neighborhood. The decorative treatment of the gable ends, with their pierced bargeboards and fish scale shingles, the pierced and scrolled brackets, and the first floor bay window with its shingled demi-mansard roof with a squeezed pediment, give rich detail to these "Victorian tract" houses.

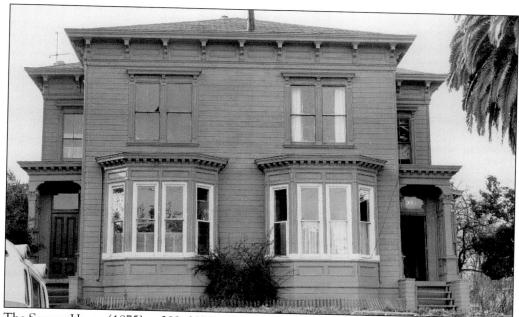

The Sawyer House (1875) at 389–397 Franklin Street is unique for its bilateral symmetry. Conceivably, it is Napa's earliest duplex. Designed as the home of Benjamin F. Sawyer and his son, French A. Sawyer, in the Italianate style, the large two-story home has identical entrances on the north and south corners.

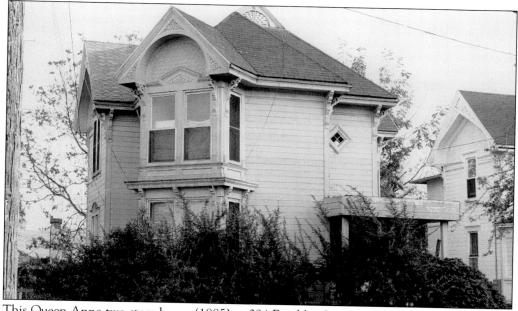

This Queen Anne two-story house (1885) at 394 Franklin Street is distinguished by the decorative treatment of the gables over the two-story bays and side extension. Though the shiplap siding of the house is relatively plain, the fish scale shingles, carving, pierced and scrolled brackets, and carved pediments over the windows of the bays give the visual display expected of the Queen Anne. It stands on a stone foundation.

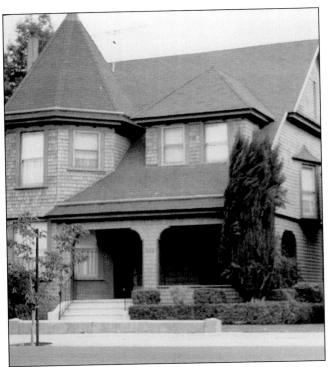

The Webber House (1906) at 482 Franklin Street is of the Shingle style with a strong Queen Anne influence in the corner tower. Note the use of shingles in the shaping of the arches and columns of the front porch and the multi-planed roof with its sweep to include the porch. The cornice with its molded details are unaltered with the exception of an enlarged window in the rear. Original landscaping includes a concrete wall next to the sidewalk and spruce and fruit trees in the side yard. Edward L. Webber, a prominent Napa attorney and state assemblyman, was born and raised in a home further down Franklin. William Coffield, the builder, constructed his own house on Franklin (429 Franklin) about the same time in the Shingle/Craftsman style.

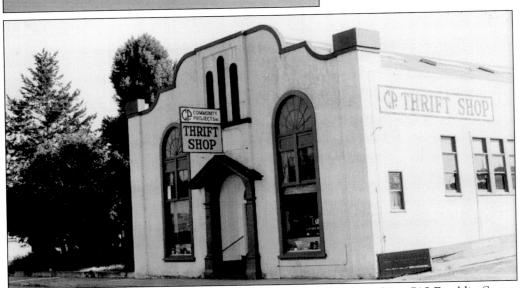

In 1905 G.W. Young announced his plans to build a "plunge bath tank" at 715 Franklin Street. The "plunge bath," or natatorium, was an early version of our swimming pools and was quite an event for the town. The original plunge was a wood frame building with a tank 30 feet by 90 feet, with a depth of 2 to 8 feet. The sides and bottom of the tank were "cemented." In 1912, the pool was floored over by the new owners, the Catholic Church, and the building was then used by the Dominican sisters for classes. The frame building was remodeled c. 1920 and was used as a school. It is probably at this time that it took on its present Spanish Colonial Revival appearance with a stucco exterior and curvilinear gable facing the street. It is now the community projects.

The Robert Sterling House (1872) at 833 Franklin is the only residence of the Italianate era of the 1870s in Napa which has the characteristic central tower identified with the Italian Villa style. In one of the most formal styles of its period, the residence reflected the position of Robert Sterling who served as one of the first directors of the Napa State Asylum (now Napa State Hospital) in 1873 and as postmaster in the 1890s. He was one of the first to arrive in Napa in 1857 and went into the lumber business, a profitable business in those first years of Napa's growth. Built of frame and shiplap construction, the Sterling House is two stories and symmetrical in plan with a three-story tower.

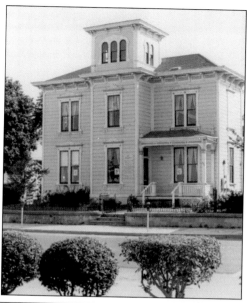

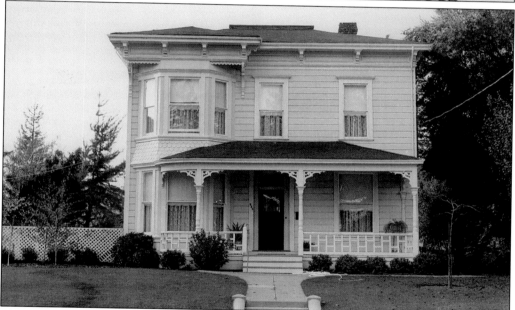

The Lord House reflects the late Queen Anne period, which reached into earlier periods for design features as well as the approaching styles of the turn of the century. It incorporates Italianate features as seen in the slanted bay window with an elaborate cornice, the low hip roof, and symmetrical plan. The porch with its puzzle work railing, turned columns, and sawn brackets is consistent with the Queen Anne. The two-story house probably once had cresting on the shallow hip roof. Photos of the early 1900s show a wood sidewalk; the concrete retaining wall is a more recent addition as is a deck off the back of the house. S.B. Merrill owned the land, originally owned by A.G. Boggs. By 1891 Merrill conceivably may have built the house. In 1903, George W. Lord, who had just moved from Nebraska with his family, took up residence. His real estate office was located on First near Brown.

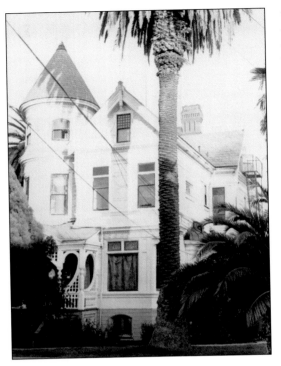

Virtually every feature identified with the Queen Anne style is present in this residence built by George Goodman Sr. for his son, George Jr. *c.* 1890. Alterations have not affected these trademarks and the George Goodman Jr. house remains one of the finest 19th century houses in Napa. The wall surfaces of the two and one-half-story house are highly textured with shiplap siding, stucco with applied stick work, and shingles. The three-story tower with a conical roof is on the northwest corner of the multi-gabled house. Curved bay windows, a pedimented entrance porch with turned and carved posts supporting latticework, stained glass panels, and a large, ornate chimney are significant features. In addition to this house, he had the residence at 1225 Division built for his son, Harvey, and his own residence was at 1120 Oak Street.

Prominent local architect Luther M. Turton designed the First United Methodist Church at 601 Randolph in the English Gothic Style. The sanctuary interior is of oak and follows the Akron plan of that time period which had an unraised pulpit and sloping floor to allow for visibility. The interior and the stained glass windows from the San Francisco Art Glass Studio in 1916 are remarkably intact. The main sanctuary also includes a lighting system, which for its time was unique. The cornice around the ceiling provides for an even glow of light by hiding without obstructing the light bulbs. The present church is the third church of the congregation first organized in 1852 by Methodist circuit riders. From its original site at Second and Coombs, the church now owns the entire block on which has been erected several additions for church and school activities. The early congregation also formed the Napa Collegiate Institute, active from 1870 to 1896, which then merged with what is now the University of the Pacific.

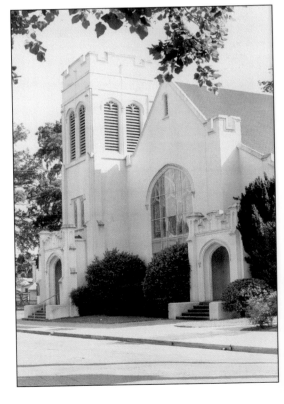

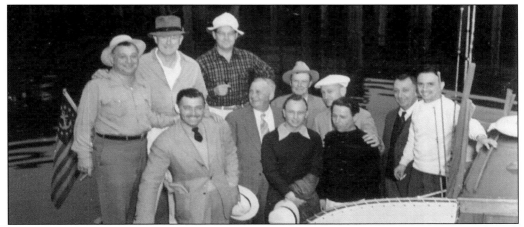

Napa's most famous insurance firm, the A.H. Smith Co., began business in 1890. J.R. (Russ) Imrie, who worked for the company from 1929–1974, stands behind Clark Gable in 1939 en route to a day of fishing. Gable was visiting Carole Lombard, who was filming *They Knew What They Wanted* with Charles Laughton. Most of the scenes were shot in Oakville. Lombard lived at 447 Randolph Street while filming.

The Andrew Sampson House at 1157 Division Street is an excellent example of the 19th-century practice in Napa of creating a two-story house by raising the original one-story cottage and building a new first floor. The original cottage, now the second floor, is believed to have been built in 1850, soon after Stephen Broadhurst bought the land near the Napa River from Joseph P. Thompson, one of Napa's first settlers. Andrew Sampson, originally from Sweden, purchased the property in 1871. He had an active role in the Napa River trade as he ran a towboat line, operated a schooner between Napa and San Francisco, and had a drayage business in Napa Valley. The house raising took place *c.* 1900. The house stands on a fieldstone foundation and is framed with shiplap siding. Andrew Sampson's wife, Olinda, planted two sequoias in the front yard in the 1870s.

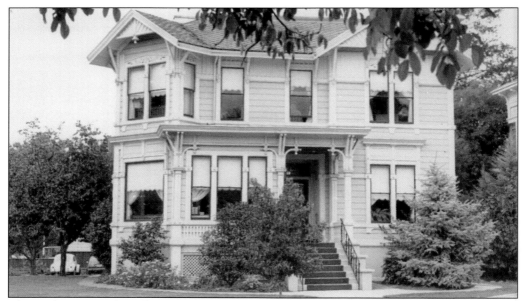

The Parker House (1880) at 1211 Division Street with its stick work embellishment, square two-story corner bay window, and elongated diagonal brackets is typical of the Stick Style of the 1880s in Napa. Vertical and diagonal stick work over the horizontal shiplap siding provide a decorative relief. Note the paired double-lintel on the second floor. Theodore R. Parker, superintendent of the early Napa Gas Works and of the privately owned Napa City Water Company, purchased the lot in 1877 and erected the house as his residence.

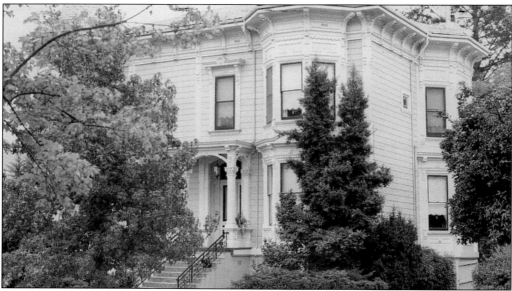

The Goodman-Corlett House at 1225 Division Street exemplifies the changing tastes from the Italianate style of the early 1880s executed in the highest style. Originally built in the Italianate style, the round corner tower with its conical roof was added several years later, introducing the Queen Anne. The Corlett family purchased the house in 1903. It was the residence of Robert Corlett, state senator in 1901 and 1903 and Napa County assessor from 1907 to 1929.

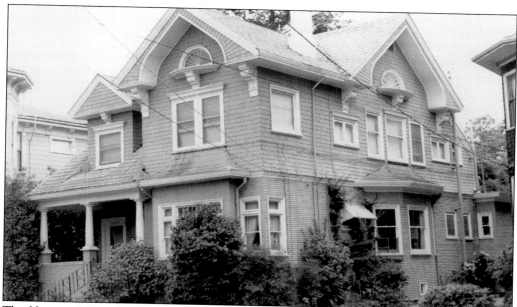

The Hayman House (1905) is an excellent example of the turn-of-the-century residences that incorporated characteristics of the several styles popular at the time: Queen Anne, Colonial Revival, and Shingle. The scale of the residence with its multi-gabled roof and massive scrolled and pierced brackets is reminiscent of the Queen Anne; the shingle surface (even as a decorative influence in the gables) and the sweeping overhang that incorporates the porch is seen in the Shingle style; the porch columns are Colonial Revival. Common to such transitional houses is the use of narrow horizontal siding on the first level and shingles on upper levels. Unusual are the fanlights in the roof peaks. Note also the first-floor windows with their one-over-one sash and transom above. John E. Hayman worked for *The Napa Register*, the local newspaper.

The Lamdin Cottage (1870), a small Victorian Gothic cottage at 1236 Division Street, predates the late-19th century Victorian residences, which line Division Street. The cottage originally stood where the Robert Lamdin House is now (590 Randolph Street) and was moved to its present location *c.* 1895 when Robert Lamdin, well-known Napa grocer, decided to build his house on the corner lot given to him by his sister. The broad gable roof with the gable end to the street suggests that the cottage was built in the Greek Revival style and perhaps later given the decorative gable trim identified with the Victorian Gothic. The one and one-half-story cottage has clapboard siding, now rarely seen in Napa, and the typical Greek Revival placement of doors and windows with the transomed door to one side and a window in the gable. Windows are six-over-six sash.

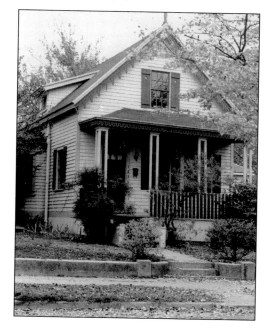

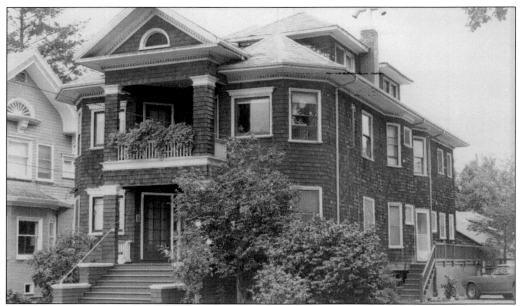

An early example of a multiple dwelling, this two and one-half-story house at 1241–1245 Division Street was built to accommodate three apartments c. 1905. The strong influences of the Colonial Revival and Shingle styles are evident. Note particularly the two story front porch with its triangular pediment and semi-circular lunette. Coarse dentils mark the cornice beneath the flattened overhanging eaves of the hip roof. Two dormers with hip roofs create a third level. The coarse dentils also mark the lintels of the front windows. Shingle siding, as is characteristic in the Shingle style, also covers the porch columns and staircase.

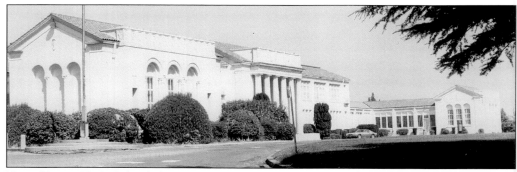

Napa Union High School dominates the major intersection of Jefferson Street and Lincoln Avenue, which was on the outskirts of town in the 1920s when this Neo-Classical school was built. In 1897, the first public high school opened in Napa in a building moved to Polk Street from Seminary Street where it had served as the Napa Ladies Seminary. The second high school opened in 1909 in a frame building on Jefferson between Clay and Polk Streets. In 1919–20, the construction of Napa Union High was approved; it was one of three schools to be built in Napa in the early 1920s. Massive and imposing as educational buildings of the period were meant to be, the two-story central block carries the main portico with its six Doric columns. Flanking wings form a "U" plan. Note the classical influence in the gables with returns and the triple semi-circular arched windows. Recent painting is revealing the fine detailing of the corbelled arches and pilasters. The Mission Revival influence of the 1920s and 1930s is seen in the tiled roof. There was an interior fire in the 1930s but the façade was unchanged.

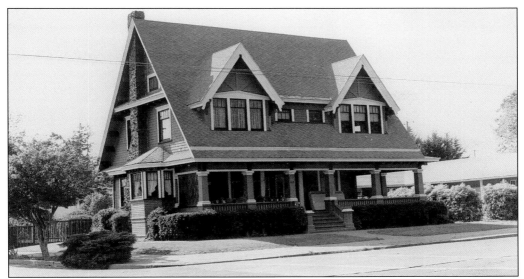

William H. Corlett, Napa architect and co-owner of the Enterprise Planing Mills on Third Street, drew the inspiration for this vernacular rendition of the Shingle style from Frank Lloyd Wright's Oak Park, Illinois designs. Corlett designs are among some of the finest in Napa County as seen in the Richie Block in St. Helena, the *St.Helena Star* office, the William Hunter House on First Street Napa, and the Franklin Station Post Office in Napa. In building his residence, Corlett chose a location in Napa's developing West Side adjacent to the new city park, Fuller Park. The Corlett House (1908–1910) at 507 Jefferson carries the steeply pitched and sweeping roofline of the Shingle style, which encompasses the porch and the massive gable end and dormers reminiscent of the Oak Park designs.

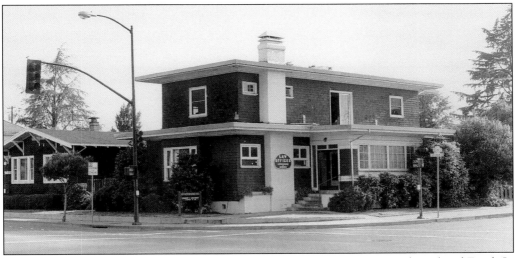

The Henry J. Manassee House (1917) at 845 Jefferson, in the avant-garde style of Frank L. Wright's prairie style house, is further evidence of Napa architect Luther Turton's versatility in such diverse structures as seen in the Semorile Building (1888), the Goodman Library (1901), and the Methodist Church (1916). The two-story, flat roofed house with projecting eaves emphasizing the horizontal lines of the first and second stories is characteristic of the style. All projecting rooms are rectangular, as are all casings and sash and the large, plain brick chimney.

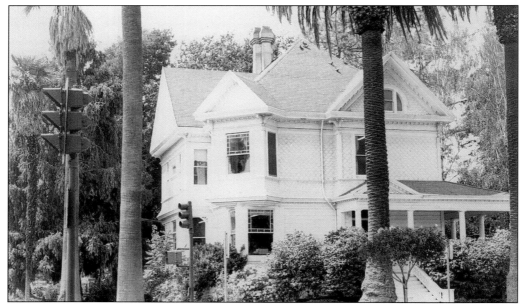

In 1892, the J.C. Noyes House at 1005 Jefferson, designed by Napa's leading architect Turton, was described as being of a "modern style," identified today as Queen Anne. Virtually unaltered, the house displays the major Queen Anne influences of varied exterior surfaces of shiplap, fish scale, and octagon shingle siding; steep, multiple gable roof with prominent triangular pediments and ornamental brick chimney. Note particularly the dentil trim of the cornice and pediments; the applied decorative in the pediment over the porch; the upper window sashes with their small geometric panes; the beveled and leaded glass of the front door; and the Colonial Revival Doric columns of the front porch and the fine turned balusters of the porch staircase. The large palms were planted in 1895.

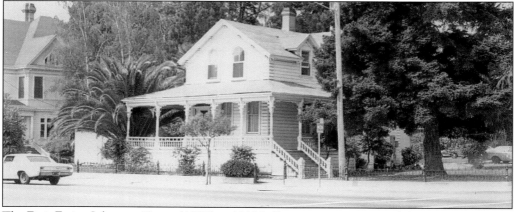

The Finis Ewing Johnston House (1875) at 1041 Jefferson represents, on a delicate scale, the pre-Victorian Greek Revival style with the gable end to the street. However, the Italianate influence is most evident in the round, arched windows on the second floor, double brackets supporting the eaves, quoins, and arcaded loggia. Finis Ewing Johnston was admitted to the bar in 1869 in Napa and practiced there until 1917, becoming one of Napa's most prominent early attorneys. He had acquired the lot in 1874 and the house was built as his residence soon after. A very fine wrought iron fence borders the property, which has been isolated by Jefferson Street.

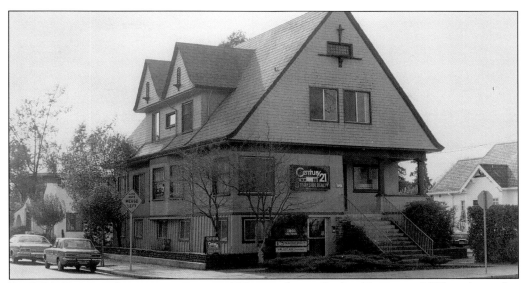

Dr. R.M. Squier, a dentist, commissioned Napa architect Luther Turton in 1905 to design his new residence at 1801 Oak and Jefferson Streets, across the street from Fuller Park. The park, the city's first, was dedicated the same year. Note the triangular pedimented gable of this vernacular rendition of the Shingle style with its paired gabled dormers based upon the Oak Park designs of Frank Lloyd Wright. Shingles cover the gable ends. Note the Turton signature detail in the gable peak drawing up of the shingles like a curtain. The two-story house sits on a raised foundation. Surface textures range from board and batten on the foundation, to narrow horizontal siding on the first floor and shingles on the second.

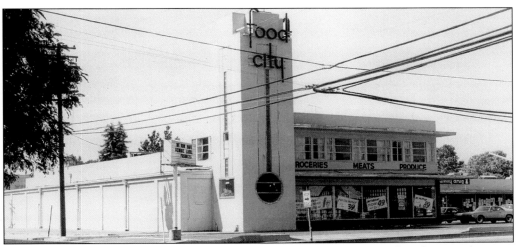

Sam Gordon Sr. developed Food City, 1805 Old Sonoma Road, Napa's first drive-in shopping center, in the late 1930s. Gordon, builder of several theaters in San Francisco, had moved to Napa in the early 1920s. He would eventually play an important role in the commercial development of downtown Napa and was the owner of the Gordon Subdivision. Food City, one of very few Art Moderne buildings in Napa County, is certainly the most dramatic. The streamlined, "wind-tunnel" look of the Art Moderne is found in the low horizontal line of the lower level storefronts and second level band of windows. Most striking is the tower with its round glass design and neon sign.

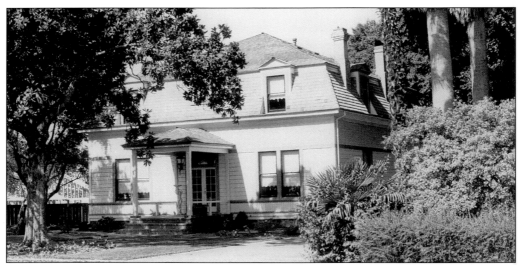

The Churchill-Dollarhide Estate at 1991 Pine Street, constructed for the prominent Napa banker Edward Churchill in 1891, illustrates the transitional period in architectural styles at the turn of the century. The large and well-landscaped estate is visually unique in this neighborhood of small cottages and bungalows reflecting a range in styles from the 1890s to the 1930s. Elements of the formal styles incorporated in the two-story redwood frame house include the mansard roof and triangular pedimented dormer windows associated with the Second Empire style, variation in exterior surfaces common to the Queen Anne, and shingle siding of the second level and simple lines characterized by the Shingle style. A.J. Dollarhide, a rancher from Pope Valley, purchased the estate soon after it was built as a town residence for his family.

F.A. and B.F. Sawyer established Sawyer Tannery, located in southern Napa near the Napa River for ease of shipping its wool and hides, in 1870–1. A major economic force in Napa County, the tannery processed the hides, tallow and wool products of the extensive stock-raising ranches, and a mainstay of the county's economy. One of several tanneries in Napa, it was the largest and one of largest on the Pacific Coast. Several tanning innovations were patented at the tannery, particularly "Napa Patent Tan" discovered by Emanuel Manassee. Many early prominent Napa families were associated with the Tannery including the Sawyers, Holdens, Nortons, and Manassees. The original frame buildings have been replaced over the years by the present buildings, which still reflect a clean industrial architecture in wood.

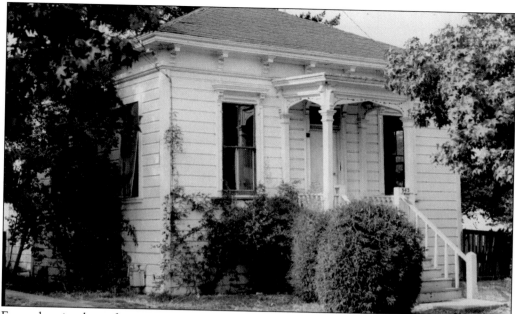

Even the simplest of cottages often picked up the decorative elements of the more formal styles as is evident in this Italianate cottage. Almost square, the one-story frame cottage at 543 Coombs duplicates the symmetry of the larger Italianates. Note also its low-pitched roof and projecting eaves supported by elaborate pierced and scrolled brackets. The molded window hoods supported by brackets top tall, narrow sash windows. The front porch could grace a much larger house with its molded cornice, columns, brackets, pierced arches, and turned balusters. In 1908, auctioneer J.T. Gamble lived here.

There are only a few examples of the Second Empire style in Napa and the Goodman Mansion (1872–3) at 1120 Oak illustrates particularly well the imposing facade with its projecting pavilion, which incorporates a two-story bay window. The distinguishing feature, the mansard roof, is convex and contains the dormers with their segmental arched windows and pediments. The molded window trim of the semi-circular arched windows has a pierced keystone and is a significant feature. Pierced brackets support the cornice with its molded gutter. Note also the recessed entryway with its marble steps and tile work. George Goodman arrived in Napa in 1855 and opened a general merchandise business. George and his brother James opened Napa's first bank in 1858. Active in mining, real estate, railroads, and viticulture, George Goodman was also a philanthropist and donated the Goodman Library to Napa.

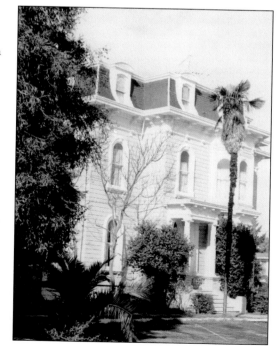

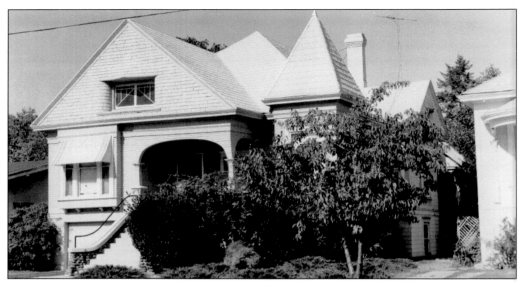

The year 1900, when William Schwarz had his residence built for his new bride, marked a major shift in style from the popular Queen Anne of the 1890s to the more open cottages and bungalows of the early-20th century. An excellent example of this transitional style, the Shwarz House at 1218 Oak Street, retained the multi-gabled roof, corner tower with its tent roof, and prominent chimney of the Queen Anne period. However, also note the narrow horizontal siding of the first story and the shingle siding of the prominent gable end, with its eyelid dormer, facing the street, characteristic of the new Bungalow and Shingle influences.

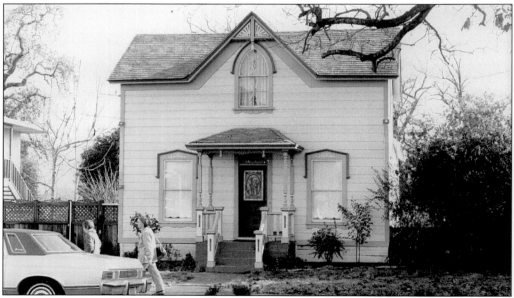

The Hammerich House (1870) at 482 Cross Street is one of Napa's finest early Gothic Revival houses. It was not unusual in 19th-century Napa to move houses around town and in 1883, F.H. Hammerich purchased this house then standing on Grant Street (now Brown Street) and moved it to its present site on Cross Street. Note the center gable with its pointed arch window and labeled molding typical of the Gothic Revival.

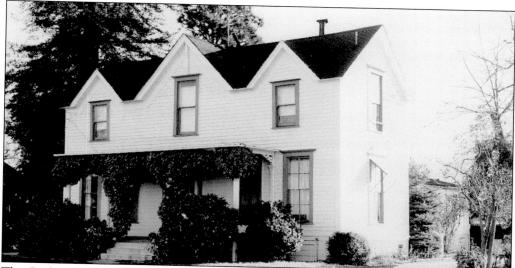

The Gothic Revival style with its central peak is found in only a few houses in this neighborhood of Napa, but the Harry Gunn House (1875) at 1429 Elm Street is unusual in that it carries three of the gabled peaks. Most likely a farmhouse originally, the Gunn House reflects a type of early building construction in which the building is only one room wide. Note the clapboard siding, which is also unusual in Napa where most frame structures have shiplap siding. Apparently, the house once stood in the center of a large lot at the corner of Elm and Franklin Streets and faced Franklin Street. Between 1901 and 1908 the house appears to have been moved to its present site facing Elm Street. Harry L. Gunn, county auditor and president of the Napa County Abstract Co., lived in the house in the early 1900s.

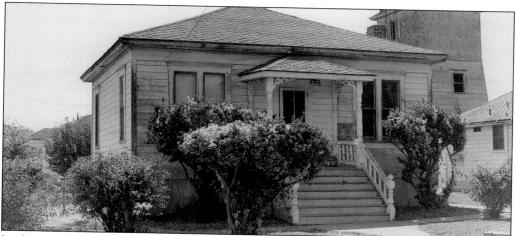

In this neighborhood of small cottages built in the 1890s and early 1900s lived many whose occupations were listed simply as laborer, clerk, glove cutter, or shoe factory worker. Typical of the early neighborhood is this cottage at 905 Jackson Street with the tank house to the rear, a once common structure in residential neighborhoods of Napa. Rectangular with shiplap siding, the one story hip roof cottage sits on a raised foundation. Windows are tall and narrow with one-over-one double-hung sash with plain moldings. Note the fine decorative turnings of the porch columns and newel posts of the stair railing and the scrolled and pierced brackets supporting the porch roof.

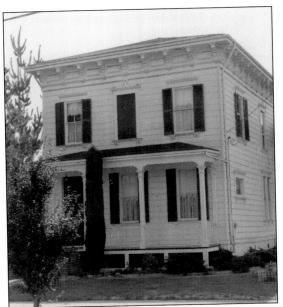

The elaborate and complicated brackets supporting the eaves of the Schuppert House (1875) at 1043 Vallejo give character to the simple rendition of the often formal Italianate style of the 1870s. The house is a fine example and one of the few Italianate houses in this area of Napa. The two-story hip roofed house with shiplap siding is rectangular and has the characteristic symmetry of first and second story windows above each other and the door to the side. Note particularly the delicately turned balusters of the porch railing, which may have been an addition of the 1880s. The windows have molded lintels and an unusual molded lugsill supported by paired brackets. A sawn decorative caps the second floor central window. Joseph Schuppert owned a billiards room and saloon on Brown Street.

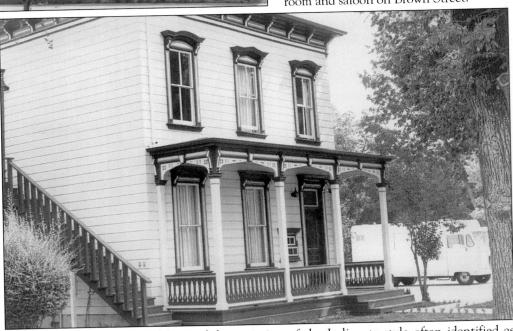

The severely straightforward lines of the variation of the Italianate style often identified as Romano-Tuscan are evident in the Buford House (1877) at 1930 Clay Street. The two-story redwood framed house with shiplap siding has the characteristic cubic form and low-pitched roof of the style. Victorian exuberance is found in the ornamentation of the cornice with its molded gutter, decorative pierced brackets supporting the wide eaves, and horizontal panels in the frieze. The narrow windows with their two-over-two sash have elaborate window hood and lintel treatments. Note the bracketed straight lintels of the first floor windows and the alternating bracketed window hoods of the second floor windows. An early two-story addition to the west side is consistent with the style.

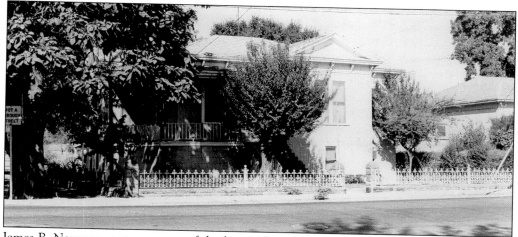

James B. Newman, a stonemason of the late-19th and early-20th centuries, built many of the early architectural landmarks in Napa County and Napa City. His residence here at 1105 Juarez Street was only a few blocks from his Marble and Granite Works located at 929 Third Street. Originally from England, Newman arrived in San Francisco in 1873, and soon after in Napa, where he went into partnership with Wing, a local mason. They opened one of the first quarries east of Napa City. Newman built the Migliavacca and Behlow Buildings, the Goodman Library, and the Old St. Helena High School. His Putah Creek Bridge, reportedly the largest stone bridge in the western U.S., is now under Lake Berryessa. Newman's residence is Queen Anne in style. One story with a raised basement it has a low hip roof, bracketed cornice, and pedimented, projecting square bay. Asbestos shingles cover the siding, but the fine iron and stone fence reflecting the Mason's art remains.

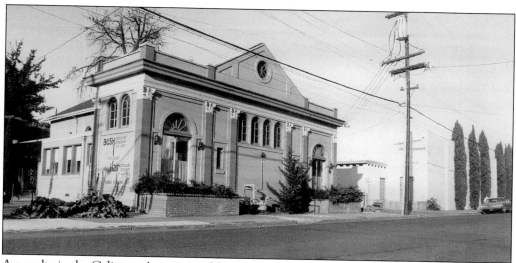

A novelty in the Calistoga Avenue neighborhood is the former Christian Science Church (1920), which suggests Romanesque Revival style. The gabled nave with circular window, the impressive flanking wings with their large one-story arched windows and the row of arched windows on the front and sides is typical of the style. Note also the pilasters with their Corinthian capitals, the strong horizontal cornice and belt courses and the low relief trim. The tracery in the arched windows of the facade is of interest. This one story building at 1527 Polk with its stucco surface has been altered with additions to the rear and side although its unique facade remains intact.

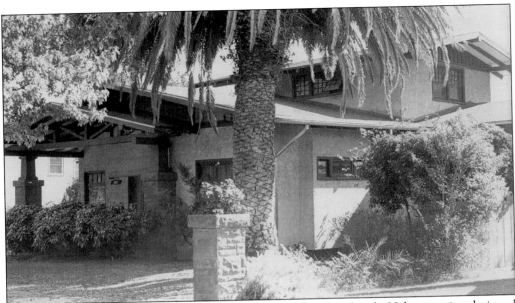

Luther M. Turton, Napa's foremost architect of the late 19th and early 20th centuries, designed this Prairie Style house at 1767 Laurel Street as his residence in 1915 and lived there until his death in 1925. The Prairie Style influence upon Turton, derived from the Midwestern architecture of Frank Lloyd Wright, came toward the end of Turton's distinguished architectural career. His compatible use of California Bungalow and Prairie style elements are evident in the low-pitched roof with extended eaves, the highlighting of the exterior stucco walls by dark wood strips, casement windows in horizontal bands, the use of small geometric lights at the tops of the windows, and masonry porch piers. Turton grew up in Napa and apprenticed with McDougall and Sons in San Francisco until 1887.

In 1905, the area known as Oak Street Park or Campbell's Grove, a square block of orchard and open land bounded by Jefferson, Oak Laurel, and Seminary Streets, was purchased by the City of Napa. Maps of the 19th century refer to it simply as Oak Street when Napa's football and baseball teams used it. The 10-acre park was named in honor of C.H. Fuller, Napa's mayor at the time.

Dominating the corner of Seminary and Pine Streets is a residence built for Eliza G. Yount, widow of George C. Yount, in 1884. George C. Yount was the first permanent white settler in Napa County in 1836, and was the holder of the vast Caymus Rancho in the central Napa Valley. The house in 1884 was described as "half Swiss and half Gothic" and the account continues, "there is no other house like it in this valley," which holds true today. Its style is characterized now as Queen Anne with a strong Eastlake influence. Note the two-story tower with a tent roof supported by scrolled brackets, the multi-planed roof with a clipped gable dormer, and the front veranda with turned columns and balusters and a triangular pediment. There is a recessed entryway with double doors. Scrolled brackets supporting the eaves also form part of the molding for the one-over-one sash windows. The two-story house with shiplap siding rests on a brick foundation. The house was sold soon after completion in 1885; Eliza Yount died in 1886.

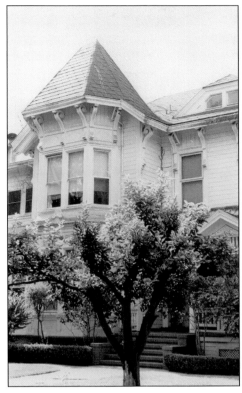

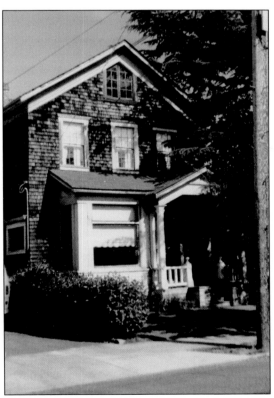

The original structure of the Seawell/Coombs House has been greatly changed. The core structure was built in 1852 at 720 Seminary Street as a residence. It was converted for use by the Napa Ladies Seminary, and then returned to residential use. It is a two-story home with the siding now covered by brown shingles of the Greek Revival style with a square bay and pedimented front entry porch. The history of this house is clouded by the many changes it went through. It was originally the home of Major John Seawell, an early pioneer in the city of Napa. The Napa Ladies Seminary used the house as its student housing and when the school closed in 1888, Judge Hartson purchased it. In 1904 Frank and Bella Coombs purchased it. Coombs was a prominent citizen of Napa, having been elected to state and national offices and was the ambassador to Japan under President Harrison in 1892. His father Nathan was one of the founders of Napa.

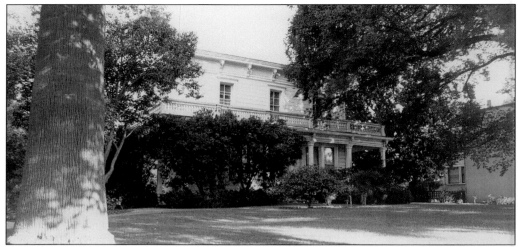

Thomas Earl erected the first commercial brick building in Napa at the corner of First and Main Streets in 1856. Earl's Hall was built adjacent to the first brick building. Lectures and "theatricals" were held there in 1857. He owned an extensive tract of land, including what is now the neighborhood around Center, Calistoga, Polk, and Seminary Streets. Early accounts refer to his residence as the first "concrete" house in Napa in 1861. It is believed the house may be the core of the present house at 1221 Seminary Street, though there is no evidence of it now. The present house, Italianate in character, has a low hip roof supported by an elaborately bracketed cornice. Note the drop pendant of each scrolled racket. Two stories with shiplap siding, the symmetrical facade has four-over-four sash windows on the second floor and two slanted bay windows on the first floor flanking a central doorway. A very fine veranda with a turned second story balustrade encircles the front and sides of the house. Shade trees surround the house and similar large trees are found throughout the neighborhood Earl developed.

Tulocay Cemetery on Coombsville Road has been in continuous use as the Napa community's burial ground from its earliest days as part of a Mexican land-grant rancho, Rancho Tulucay, in the 1850s to the present. Rancho Tulucay originally covered two leagues and was awarded to Don Cayetano Juarez in 1841 for his services in the military in California. Livestock grazed on the rolling hills now part of the cemetery. In 1858 the land for the cemetery was donated to the City of Napa. Hillsides of the cemetery have been quarried for their basalt stone and many of the monuments are in the tradition of fine stone craftsmanship seen throughout the county. Many of the crypts are unique; they are of native stone as well as imported marbles. The present walls of the cemetery, erected in 1880, have been greatly modified and the original ornamental gates are gone. The Juarez family burial site is located there.

Pictured are the Switzer Brothers Moving and Drayage at the Duffy Mausoleum, within Tulocay Cemetery. This photo was taken after 1914 when Agnes Duffy died and the mausoleum was built.

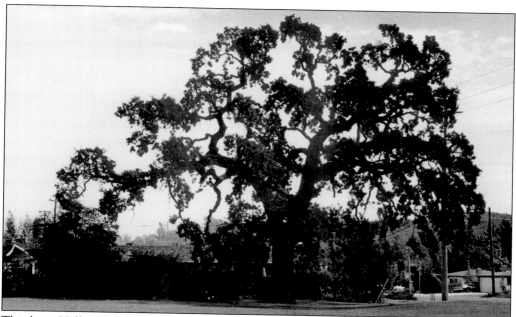

This large Valley Oak (*Quercus lobata*), a landmark on Browns Valley Road, is one of few oak trees of such age and girth in the City of Napa and is the only such tree in the city with public access allowing it to be studied and enjoyed. Estimated to be 200–300 years old, the Century Oak is 10 feet in circumference and has an 80-foot drip line. In good health, it has not been radically pruned or altered. Over the years the Century Oak has given its name to the surrounding park, a neighboring subdivision, and a popular advertising logo.

The Browns Valley Road Monument commemorates the civic action of the people of the Browns Valley district who were the first people in California to directly levy a tax upon themselves to raise funds for the construction of macadam roads. In 1908 Supervisor Partrick of the West Napa District formulated the plan for building a macadamized road in Browns Valley. On May 29, 1909, the people of the district taxed themselves 63 cents on each $100 of assessed property for three years to raise the funds. The stone monument, constructed by Napa stonemason, J.B. Newman, measures 3 feet by 3 feet by 5 feet and is located 100 feet south of Browns Valley Road at the intersection of Woodlawn Drive under a large acacia tree on the north bank of the South Branch of the Napa Creek. The inscription reads: "Erected as a memorial to the public spirited citizens of Browns Valley Road District—The first people in California to vote a direct tax upon themselves for building a macadamized road. Legal services donated by Theo A. Bell. May 17, 1911. Erected by Jasper N. Partrick, Supervisor West Napa."

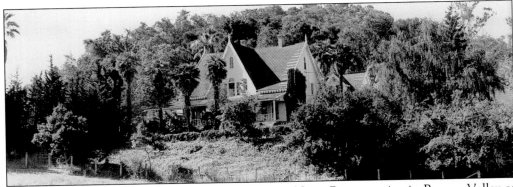

Horatio Amesbury was one of the first orchardists in Napa County active in Browns Valley as early as 1852. His residence (1860) at 3067 Browns Valley Road, situated on a knoll, still retains its original setting though many of the ornamental trees and gardens for which it was known have disappeared. It has an unusually steep-pitched central gable, a version rarely seen here of Downing's picturesque "rural Gothic style" popularized in his 1842 book, Cottage Residences. Also unusual is the basic form of the house, which is a "saltbox shape" with Gothic Revival facade. The saltbox, a New England Colonial form, would have been familiar to Amesbury, who was originally from Connecticut. The two and one-half-story frame house retains its original decorative bargeboard and finials and has a fine Palladian window in the central gable; semi-circular arched windows are in the gable peaks. The original front portico has been expanded to a veranda the full length.

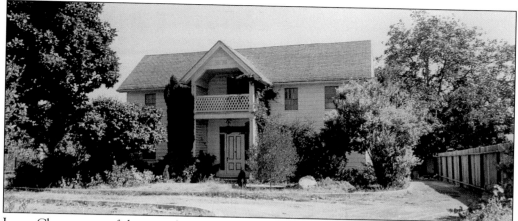

James Clyman, one of the most famous of the mountain men who opened the trails through the Rockies in the 1820s and eventually through the Sierras in the next decade, arrived in Napa County in 1845. Originally from Virginia, Clyman served with Ashley's expedition up the Missouri in 1823 and was in the Salt Lake region in 1824–27. Clyman established his farm northwest of Napa City c. 1850 and the farmhouse still stands though now surrounded by residential suburbs. The two-story Greek Revival farmhouse (1858) at 2243 Redwood Road with clapboard siding is "L-shape" in plan with a projecting front portico and a second story balcony and gabled roof.

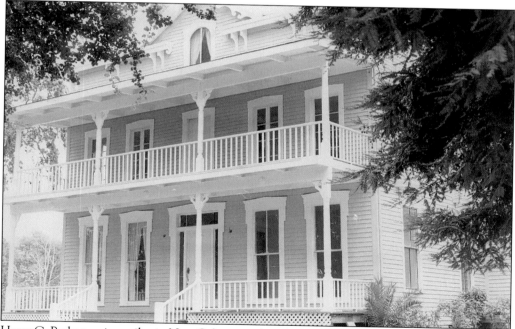

Harry C. Parker, a river pilot in New Orleans in the 1840s, arrived in San Francisco in 1849 during the Gold Rush. A merchant in Stockton and in San Francisco, he arrived in Napa County in 1865 and engaged in farming. His residence (1870) at 4066 St. Helena Highway is a Gothic Revival house with a distinctive Southern character. It has been modified in only minor details and stands as one of the finest of Napa County's early frame buildings. The two and one-half-story house with clapboard siding has chimneys at the gable ends, a "Gothic peak" in the center with an arched window, and characteristic decorative gingerbread bargeboards.

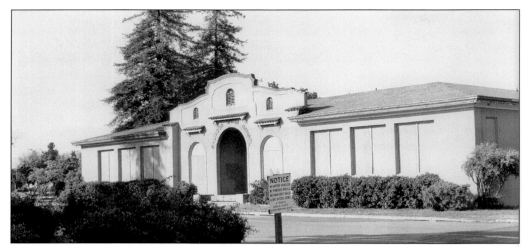

In the 1920s, as independent school districts consolidated, the third Salvador School was built at 1850 Salvador Avenue. It reflects the popular Mission Revival style of the period and was a spacious one-story building with an auditorium, library, and four classrooms. Two Salvador schools had preceded it at the site of what is now 4105 Big Ranch Road. The first frame school built in 1868 burned. In 1893, the second frame school was built on the same site and is today a residence. In 1922, the schools moved to Salvador Avenue. Additional rooms were added in 1948 and 1953. By 1966, the students had moved into classrooms in adjacent buildings. The old Mission style school is a reminder of its central place in the community as a community center, a church, a dance hall, and a basketball gymnasium over the years.

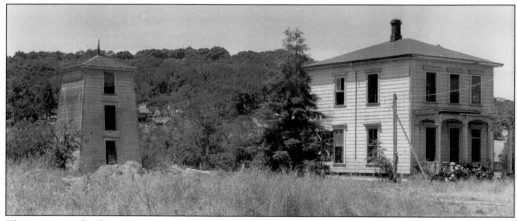

The countryside along Hagen Road has retained the openness of this 19th-century farming region east of Napa City. The Bergstrom House, 1225 Hagen Road, believed to have been built in the 1870s for the Hudson family, was purchased by the Bergstroms in the late 1880s or 1890 and re-mained in the family until a few years ago. The two-story house follows the severely simple lines of a variation of the Italianate style identified as Romano-Tuscan. Characteristically symmetrical in appearance, this early "country" house has a hip roof with a central brick chimney. Siding is of shiplap. Decoration is limited to the shelf hoods over the tall, narrow windows and to the sawn and pierced brackets supporting the porch overhang. Note also the sawn balustrade of the porch and the square porch columns. Door placement is to one side as is typical, with a transomed door. A stone cold room or smokehouse remains, as does the three-story water tower, which mimics the lines of the house; both are reminiscent of early self-sufficient ranches.

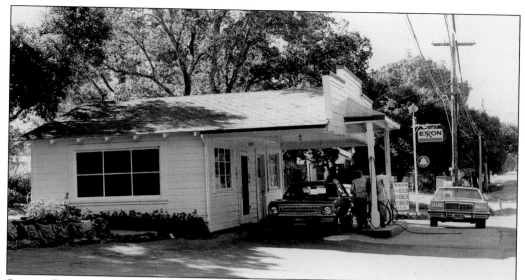

Some still remember the first Reo cars that appeared in Napa County soon after the turn of the century and the gradual transition of many livery stables into garages. John Grippi's Gas Station at 1802 Silverado Trail was one of the few stations of that era. The familiar stepped false front is seen in country stores of the 1920s and 1930s in the county. Here vernacular style is used in a one-story frame building with shiplap siding. A jutting portico in front with a false-front cornice provided a drive-through for cars and protection for the gas pumps. The false front, supported by two square, wood columns, conceals the gable roof. Rafters are exposed, which was also a feature of the 1920s. Windows are large and horizontal with the enclosed used as an office.

E.W. Doughty, well-known contractor in Napa in the late-19th and 20th centuries, built this Spanish Colonial Revival at 589 Trancas Street for himself in 1918; it stands as one of the early concrete residences in Napa. Doughty was an innovative contractor and was responsible for both residential and civic/commercial structures, notably the Noyes Mansion, the William Hunter House, and St. Mary's Church among many. Note the low, horizontal of the two-story house with its tiled, low hip roof and stylized rafters. This Spanish Colonial Revival influence is seen also in the projecting one-story entry portico with a tiled hip roof supported by massive concrete columns. Smooth plastered wall surfaces are plain. Also note the upper level windows, which have a hinged multi-paned transom and a pivoting lower pane.

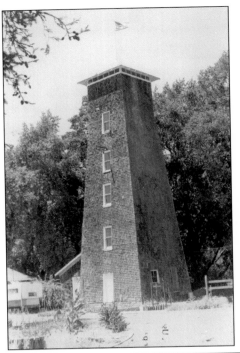

The Doughty Tank House is believed to be the largest non-industrial water tower in Napa County and in size, construction methods, and functional design is unsurpassed. The six-story tank house, built along the lines of lighthouses, was needed to provide sufficient pressure to irrigate the extensive vineyards, alfalfa fields, and orchards on the property. At the time the tank house was built the saltwater line had not extended up the Napa River as far as Trancas, which it now does. A unique feature tank house is the utilization of the large rooms within it for cold rooms and storage. Note the shingle siding, which conforms to the siding of a two-story shingle building, which was moved off the site adjacent to the tank house to make room for the new Doughty residence. The shingle house and a smaller one remain on the property.

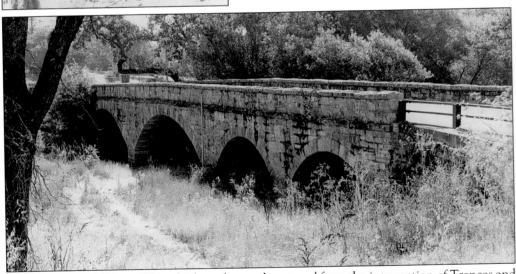

Monticello Road (Hwy. 128), which angles northeastward from the intersection of Trancas and Silverado Trail, carried a steady traffic of freight wagons in the late-19th and early-20th centuries to and from the rich Berryessa Valley. Teams would line up to ford Milliken Creek and the Napa River on Trancas Avenue. Stone bridges, proven durable and economically competitive in this region of stone quarries in the 1890s, replaced earlier wood bridges and fords. Milliken Creek Bridge, constructed in 1908 by H.W. Wing of Napa, is one of 60 or more bridges in Napa County of native stone; some multi-spanned such as this four-span bridge, some little more than stone culverts. The cut stone quarried locally was used in the style common to bridges throughout the County. O.H. Buckman, city engineer, supervised for the Milliken Creek Bridge as he did for several in the county.

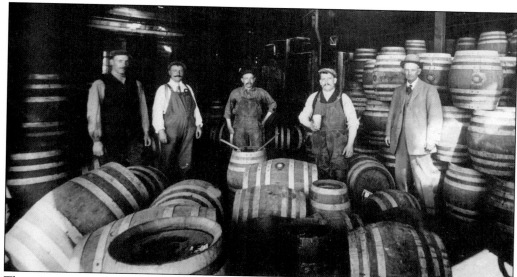

This picture was taken on Friday, April 5, 1907, at the Western Cider Works, Soscol and Sixth, in Napa. We see from left to right: George Zimmerman, George Blaufuss Sr., Mark Schultz, Mike Knecht, and Ed Churchill. When the name was changed to Saxon Ciderworks, legendary Willie Mays was selected as a radio spokesperson for the product. He was asked to say, "Saxon Cider works for me, I know it will work for you." However, listeners interpreted him as saying, "Sex on Cider works for me, I know it will work for you." Business boomed.

The Old Adobe at 376 Soscol Avenue is one of only two standing adobe buildings in Napa County and is a significant reminder of the Mexican land-grant period in Napa County when Rancho Tulucay, on which it is located, was created in 1841. Don Cayetano Juarez, a native Californian and military man, was rewarded for his part in Indian expeditions by the Rancho Tulucay grant of two leagues, covering much of southeastern Napa City. He grazed his cattle on the ranch as early as 1837 and built the first of two adobe buildings in 1840. This, the second and larger adobe structure built in 1845, is believed to be the Old Adobe still standing. A low overhanging roof, wood porches on the east and west, and corner additions, all of a later date, enclose the Old Adobe. The walls of adobe mud bricks are plastered and painted, the north wall is of exposed brick. On this wall is an outside entrance to the second story attic entrance reached only by ladder. Doors and window shutters are of rough-hewn wood.

White Sulphur Springs, named for the famous spa in West Virginia, was first opened as a retreat in 1851 and as a spa in the following years. Napa County pioneers John York and David Hudson discovered the springs, one hot and six cold, in 1848. Sven Alstrom, who was a partner in the Oriental and Lick House hotels in San Francisco, was proprietor of White Sulphur Springs from 1861 to 1880.

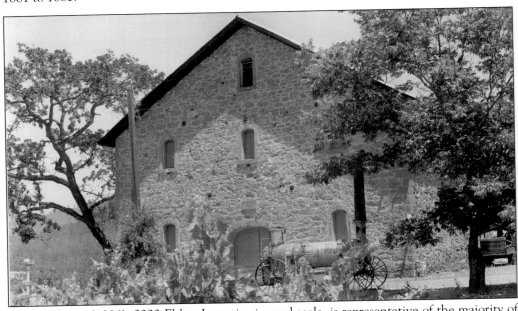

Ehlers Winery (1886), 3222 Ehlers Lane, in size and scale, is representative of the majority of wineries in Napa County during the viticultural boom in the 1880s when most wineries were small or medium size and family run. Of native fieldstone, the vernacular winery is characteristically rectangular with a gable roof and the gable end facing the main road, which is some distance away. Variations in stone texture suggest more than one builder was involved or that construction was carried out in several phases.

Two

ST. HELENA

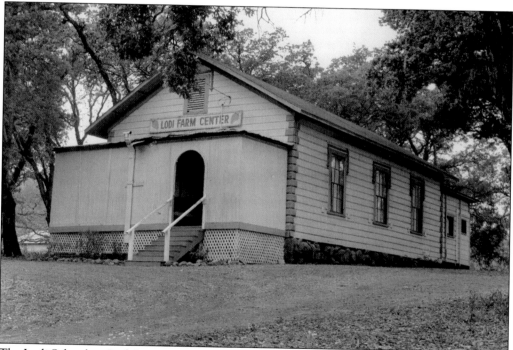

The Lodi School on Lodi Lane is an early example of the one room schoolhouse in Napa County which followed a simple rectangular shape with a broad gable roof, yet the decorative detailing of the corner quoins in wood and the hood molds with a corbel stop is highly unusual, reflecting a mixture of styles of the 1870s. The frame building with shiplap siding sits on a fieldstone foundation which is clearly visible. Windows line the sidewalls and are of double sash with six lights each. An enclosed porch has been added to the front, which conceals the recessed entryway, and there is also an extension to the rear. Schools in the agricultural valleys of the county always have been a center for community activity and the Lodi School's use now as a Farm Center continues that tradition.

The York Winery (1877), 1095 Lodi Lane, of native fieldstone, is similar in masonry construction to the E. Silas York residence on adjacent property on Lodi Lane. Silas York, a member of the early pioneer York family, raised nursery vineyard stock in addition to managing this winery. Typical of the many small family owned wineries of the mid-19th century, the York Winery is of two stories with a hip roof. Corner quoins are of cut stone as are the semi-circular arched window moldings with a central keystone. Segmental arched doorways have cut-stone lintels and quoins. Note the central cupola with its clustered square columns and brackets supporting the tent roof.

The Italianate style so popular in Napa County in the 1870s is usually seen in wood; the residence, 1005 Lodi Lane, of native cut stone built for Silas York, is a rare example of the style in stone and is one of few stone residences in the county. Trees conceal the facade of the native cut-stone two-story building which has the characteristic symmetry of the Italianate style with wood scrolled brackets supporting the low hip roof. Paired semi-circular arched windows with their cut-stone hood moldings with a keystone are an unusual feature. Note also the semi-circular arched doorway with its double doors and transom. Stone square columns support the wood cornice of the entry porch. An early extension to one side is of fieldstone of a different masonry technique and the present owners enclosed a porch. The Alexander family, prominent in St. Helena banking, lived here prior to moving to Alexander Court in St. Helena in the early 1900s.

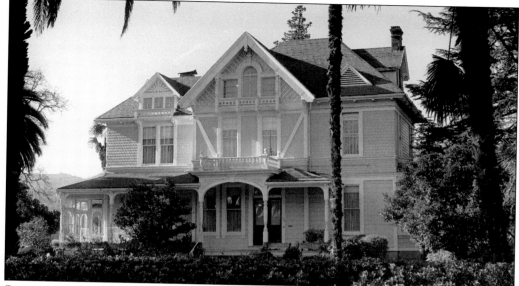

Swiss winemaker John Thomann in 1884 moved from a simple gable roof cottage to his new home, Chalet Bernensis, a residence in the highest fashion of the 1880s. The two and one-half-story frame house at 225 St. Helena Highway (Highway 29) is an excellent restored example of the Stick Style with its decorative diagonal bracing, multi-gabled and pitched roof, gabled dormers, and wide veranda sweeping around two sides. The varied surface treatments of shiplap, shingle, and smooth surface add to the decorative effect of the horizontal, vertical, and diagonal stick work.

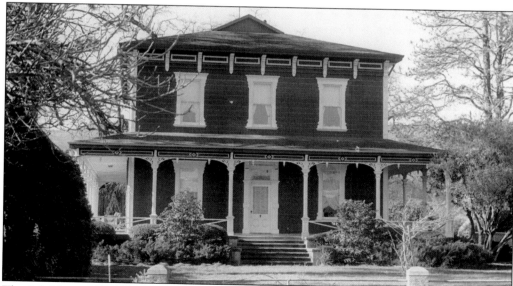

The Ink House, 1575 St. Helena Highway (Hwy. 29), the main house of Theron Ink's Helios Ranch, was built in the Italianate style with an observatory topping the low hip roof, a feature rarely found in Napa County. The observatory has since been removed but the name "the Ink-well" remains. The house, begun in 1884 and completed in 1886, has stood as a landmark for travelers on the main north-south route in the county.

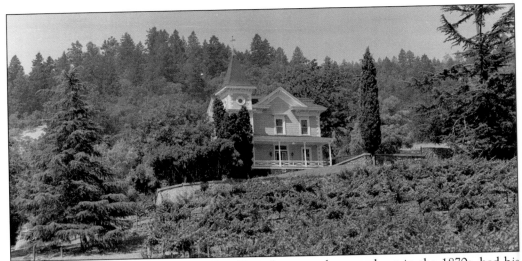

Like many wealthy San Franciscans, Fritz Rosenbaum, a glass merchant in the 1870s, had his country residence in Napa County. "Johannaberg Vineyards" at 2867 St. Helena Highway was the name of this Victorian Gothic residence on the western hillside overlooking the northern Napa Valley. Characteristic of the Gothic style is the bracketed center gable with a return. Note the bracketed cornice which supports the eaves. The two-story frame house with shiplap siding has prominent quoins at the corners. The three-story corner tower with a tent roof, quoins, and octagonal window is most often associated with the Queen Anne style, which was coming into vogue. Windows are of one-over-one sash with bracketed shelf lintels on the second story. Double doors with a transom open onto the front porch supported by square columns, which extend the front length of the building. It is known now as St. Clements Vineyard.

The Kellogg-Lyman House, adjacent to the Old Bale Mill at 3351 North St. Helena Highway, is believed to be the oldest frame structure in the Upper Napa Valley. It was constructed in 1849 as his residence by F.E. Kellogg, builder of the Bale Grist Mill. W.W. Lyman Sr. purchased the Kellogg ranch c. 1871 when he also acquired the mill. The Lyman family operated the mill until 1905 as well as the El Molino wine cellar, which they built in 1871 and operated until 1910. In 1921 W.W. Lyman Sr. died and in 1923, the family gave the Bale Mill to the Native Sons of the Golden West. It is now operated as a state historic park.

The Bale Grist Mill, three miles northwest of St. Helena with its overshot wheel, stands not only as a technological achievement of the 1840s but also marks a significant era in California's agricultural history when the grist mill was vital to the grain producing areas. The mill stands on a sloping hill giving it three stories in front and two stories in the rear. Of clapboard, with a shiplap false front facade, the mill stands on a fieldstone foundation. The millpond, fed by Mill Creek, provided waterpower to the wheel. Dr. Bale, holder of the Mexican land grant, Carne Humana, which encompassed most of the upper Napa Valley, commissioned F.E. Kellogg to build the mill. A steam engine was added in the 1860s to provide power when the pond was low. In 1871, W.W. Lyman Sr. purchased the mill and added a turbine engine in 1879. The mill was in use until 1905. The granary, built at the same time as the mill, stands to the south. In 1941 the mill was given to Napa County. It is on the National Register and is state landmark #359.

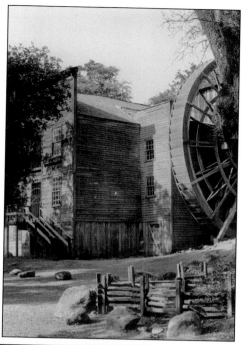

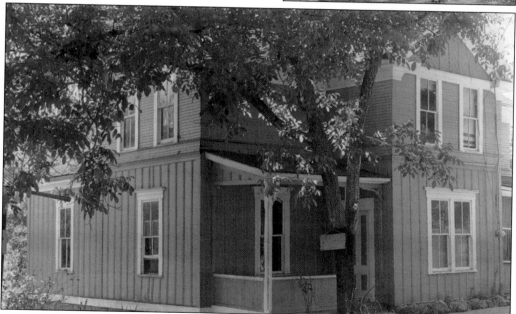

A vernacular building reflecting the Swiss heritage of its owner-builder, Anton Nichelini, the Nichelini Winery at 2950 Sage Canyon Road is still operated by third generation members of the Nichelini family in the stone and frame building constructed in 1890. Unaltered in its design, the one story native stone winery with a two-story frame residence above it is unusual in Napa County; primarily European immigrants built the few that exist. Such winery-residences are common in Europe. The stone winery of local stone was built first into the hillside below Sage Canyon Road.

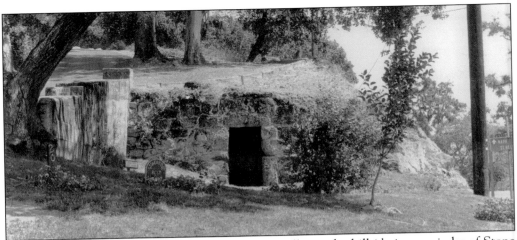

Only this grassy knoll with the remains of a stone cellar in the hillside is a reminder of Stone Bridge Saloon (1894), otherwise known as "Mother Kruger's joy house," St. Helena's one-house red light district at the intersection of Pope Street and the Silverado Trail. Only in recent years was the frame house on the knoll razed. The house and its inhabitants are still remembered today by several generations in the county. Stone Bridge Saloon took its name from the Stone Bridge (Pope Street Bridge), which was built in 1894 and stands across the Trail from the knoll. The Bridge and County Road carried heavy traffic past the door. Even today the site of Stone Bridge Saloon provides comic relief with the knoll carefully tended and a memorial marker solemnly commemorating the spot of this 19th and early-20th century way and lay station.

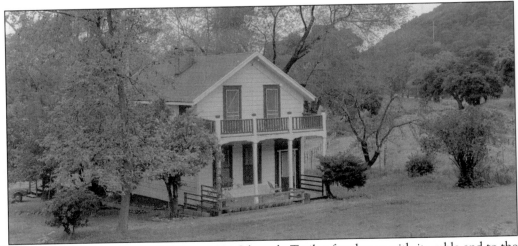

The John O. Taplin House (1870) at 1121 Silverado Trail, a farmhouse with its gable end to the road in the Greek Revival style, was once part of the lands of the Taplin Dairy, which was established c. 1872. At the time, though dairying was important in Napa County, the Taplin Dairy was the only "creamery" in this part of the county well into the early 20th century. The rectangular frame building with shiplap siding and a two-story porch has a central fireplace and chimney. Plain molded trim surrounds doors and windows and the door is to one side in the gable end, which is characteristic. Note the transom over the door. John Orange Taplin arrived in San Francisco in 1856 from Vermont and started a dairy business "at the mission." In 1870 he moved near St. Helena and started the dairy, which was later managed by his sons, John and William. The Taplin Dairy subsequently became the Connolly Dairy, but now the lands have been broken up.

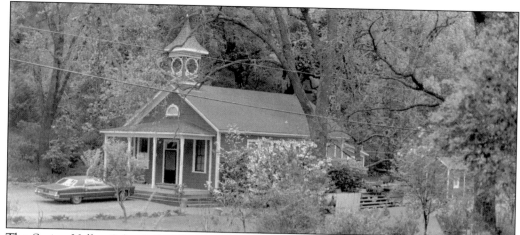

The Spring Valley School (1894) at the intersection of Taplin Road (originally Spring Valley Road) and the Silverado Trail is perhaps everyone's image of what a one-room schoolhouse should be and has been remarkably preserved in its original design details in the process of conversion to a residence. The gable roofed schoolhouse faces gable end to the road as was typical of most of the schools. A projecting porch protects the transomed doorway in the gable end. Double-hung sash windows with four-over-four panes flank the door and line up along each side of the building. A half-round ventilation window is above the porch. The open bell tower with its tent roof is whimsically decorative but was very serviceable in its time.

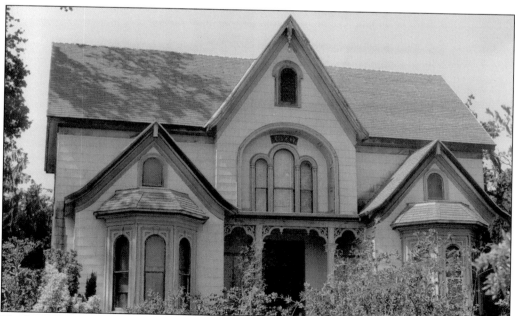

The Lewelling House (1870) at 2093 Sulphur Springs Avenue, St. Helena, a Victorian Gothic residence constructed for John Lewelling, a horticulturalist and viticulturalist known throughout California in the mid-19th century for his experiments in fruit and nut propagation and dehydration, is perhaps unequalled in Napa County in its display of several architectural styles popular in the 1870s. The two-story frame house carries the central Gothic peak in the roofline and two gable roofed bays.

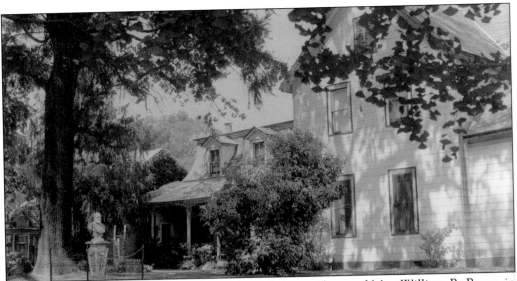

At 2233 Sulphur Springs Avenue is "Madrono," the residence of Mrs. William B. Bourn in the late 19th and early 20th century. The Bourn family, long prominent in San Francisco, was equally active in St. Helena. Sarah Esther Bourn managed vineyard acreage on her Napa County estate as well as experimenting in silkworm cultivation. Her son, William B. Bourn II, a well-known financier of the period, owned the San Francisco Spring Valley Water Company and the Empire Mine in addition to his Bourn and Wise Greystone Cellars.

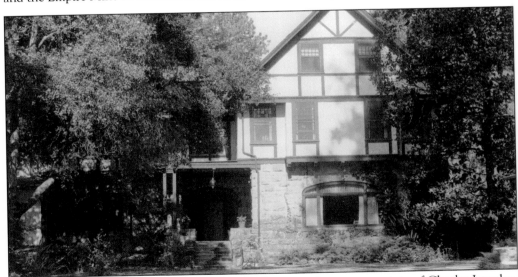

Villa Arbutus (1870) at 2455 Sulphur Springs Avenue, the country estate of Charles Langley, prominent San Francisco drug business owner, was one of several estates built along the fashionable "Avenue" approach to the White Sulphur Springs Resort in the 1870s. The Italianate influence is most evident in this vernacular style, which is essentially a simple two-story farmhouse with a gable roof which has been given the finely detailed brackets and window forms of the Italianate style in vogue in the 1870s. The balustrade of the two-story veranda was duplicated in the renovation. An upstairs sleeping porch was enclosed and there have been alterations to the rear. The landscaping of the property was noted in 19th-century accounts.

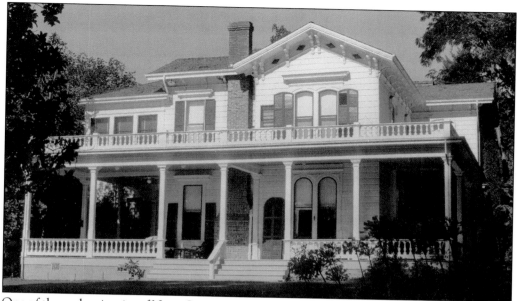

One of the early wineries of Napa County, the Edgehill Winery (1867) at 2585 Sulphur Springs Avenue, St. Helena, was built by Mr. Dowdell of St. Helena for General Keyes. The winery, part of the large Edgehill Estate, was built on the hillside above Sulphur Springs Avenue to utilize the three levels for loading and unloading the grapes for crushing and to move the wine via gravity-flow. Of native stone, the winery is 50 feet by 100 feet, rectangular, and three stories in height with a ground level basement. In 1920 the winery was converted to a residence and many features were added.

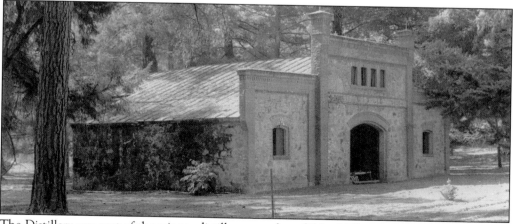

The Distillery was part of the winery-distillery complex of Edge Hill, an estate first developed by General Keyes and later by the Heath family and William Scheffler. Although the winery has been converted to a residence, the distillery remains unaltered as an unusually fine example of a 19th century industrial building. The false-front building of native fieldstone with brick detailing is one and one-half stories. Note the stepped false front of stone with the brick detailing of corners and cornice. Segmental arched windows have radiating brick lintels, as does the central doorway. Four small windows of brick are above the doorway and the battlement has flanking brick towers. This elaborate false front conceals a building of fieldstone with a gable roof. One of the early bunkhouses for the workers of the complex now stands across Sulphur Springs Avenue.

These stables (1875) once served the large vineyard estate of Edge Hill. Though the residence has burned, the other buildings remain in a setting little altered since the 19th century. The Edge Hill Stables, 2727 Sulphur Springs Avenue, of board and batten frame construction, has a central two-story core with flanking one-story wings. The gable roof has decorative gable trim and simple shed roofs cover the wings. One wing has a pass-through; apparently the other was once open but has been enclosed. In the two-story core, windows with double-hung six-over-six sash are on each side of the central double door. A smaller door is on the second level also with windows on each side. The open land once surrounding the stables was once planted in vines.

The Edge Hill Carriage House remains standing, not far from the site of the original residence. Note the Victorian Gothic detailing of the rectangular two-story building, which was very likely designed to complement the now lost house. The gable-roofed building has the characteristic "Gothic peak" with gable trim and unusual pointed arch detailing over the second floor door openings and a squeezed pediment over the gable end doorway of the first floor. Sawn decoratives surround the first floor windows. A central ventilation cupola also carries the Gothic trim along the eaves. The open countryside around the Carriage House has altered little since the 1880s.

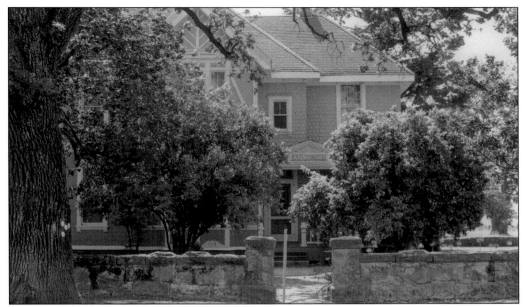

Melrose Farm, 493 Zinfandel Lane, is in the decorative Stick style, which was easily adaptable to the larger residences of the prosperous farms of the 1880s. Here the influences of the Queen Anne style are also evident in the multi-planed roof and the varying wall textures. Note the shiplap siding on the first story, the fish scale shingles of the second story, and the smooth surfaces with their stick work on the second story and the gable ends. The entry porch carries a pediment with a rising sun motif and the year "Anno 1883."

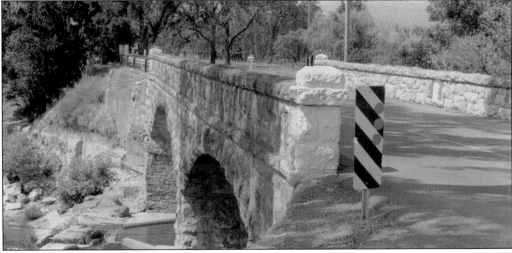

The Zinfandel Bridge at Zinfandel Lane near the Silverado Trail, a two-span bridge of locally quarried stone, was built by James B. Newman in 1913 and is the second largest stone bridge spanning the Napa River; the largest is the Pope Street Bridge. Newman, who had his Marble and Granite Works in Napa, was a stonemason known throughout the county and was responsible for the construction of many of Napa County's stone bridges. The force of the water passing beneath the Zinfandel Bridge has eroded the banks. Concrete now supports the embankment and base of the bridge piers.

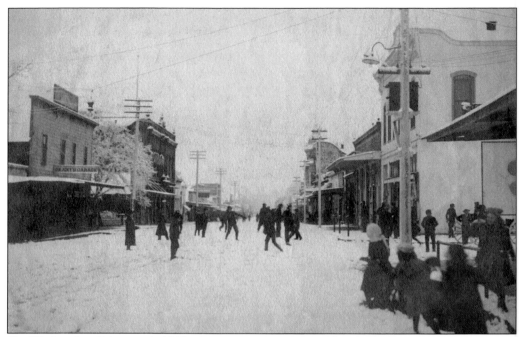

On Wednesday, February 4, 1903, a rare snowstorm occurred on Main Street, St. Helena. The year 2001 marks the 125th anniversary of this town.

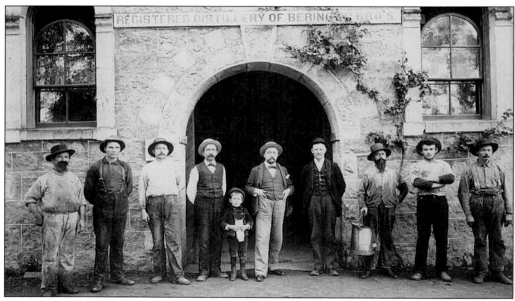

Pictured here are workers and family members at Beringer Winery on Thursday, October 18, 1894. Jacob Beringer ran the winery while Frederick provided the money. In work shoes and vest, the industrious vintner is pictured with his wealthy brother and several workers. Between them is six-year-old Charles, Jacob's youngest son, who would one day be winery president. A cellar man's day was long, the pay was low, and shirtsleeves stained to the elbows with grape juice marked his trade.

Three

CALISTOGA

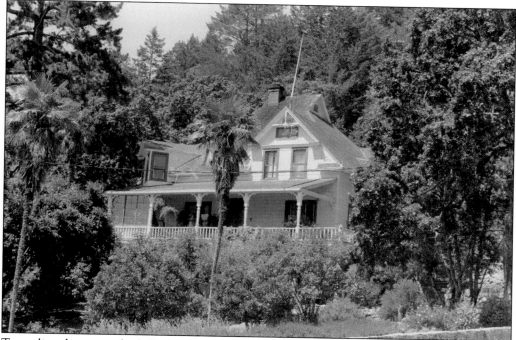

Tunneling deep into the hillside, Jacob Schramm, his family, and Chinese workers created the first aging caves and hillside winery in Napa County in 1862. By the late 1860s, viticulture would have a marked impact on the economy of Napa County, an impact that reached its height in the 1880s. Schramsberg became the widely recognized name of the mountain vineyards, residence, and wines of Jacob Schramm. Robert Louis Stevenson would write of his visit to Schramm in 1880 in *The Silverado Squatters*. Jacob Schramm arrived in Napa County in 1862. He established first his winery and vineyards and later his residence, which has had additions over the years. The first level of native cut stone served as a wine cellar. The two-story frame house has a Queen Anne character with a multi-gabled roof with gabled dormers and a triangular pedimented gable with decorative shingles and carved panels. Turned columns support the front porch with curved brackets reflecting an Eastlake influence.

Early historical accounts refer to many log buildings constructed by early settlers and lumbering and mining companies in Napa County; some of the log buildings were still standing within recent memory. This log barn, in a clearing on the Lawley Old Toll Road, is believed to be the only log barn remaining in virtually unaltered condition in the county. The barn was part of a small ranch, which raised almonds and may have had grapes under cultivation at one time. Stages on the Lawley Toll Road passed the barn regularly, for it was on the main thoroughfare crossing the mountain range between Napa and Lake Counties from the 1860s to the 1920s. A half-mile beyond the small ranch was a resting place for the horses making the long pull up the steep Toll Road. The barn, built c. 1890, is one story and rectangular. Logs form the walls, with vertical planks filling in the gable ends. The wide sloping gable roof has the original split shakes. A double door is centered in the sidewall with two square windows on each side.

The main floor of the mill at the Sharpsteen Ranch, Highway 128, is the only evidence today of the Callustro Manufacturing Company, a corporation formed in 1888 by a group of Napa County women to manufacture and distribute a powder cleanser from locally quarried rock. The mill was built into the hillside to allow roads to reach the three levels. Of redwood board and batten siding, the mill had plank flooring of Douglas fir. Mrs. Emma P. Eels discovered the rock on her land c. 1885 and noticed its cleansing properties. The company was formed and the mill built to crush the rock.

The Rasmussen Ranch (1896), 2121 Diamond Mountain Road, is typical of the mountain vineyards established in the 19th century in Napa County. A one and one-half-story gable roof cottage with a one-story extension to the rear, the house was originally faced in redwood shiplap siding, which was shingled c. 1915. An open porch at the front and side of the house was enclosed in the early 1900s. A one and one-half-story gable roof carriage house of redwood shiplap siding stands to the rear of the house and a barn of redwood vertical siding is separated from the house by orchard and vineyard. A dry stonewall runs along one side of the barn.

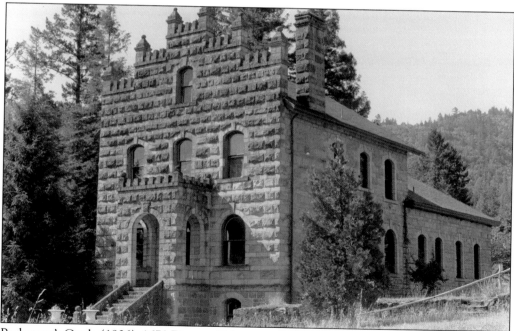

Pacheteau's Castle (1906), 1670 Diamond Mountain Road, a unique and highly original residence of native stone with a stone false front, appears out of place in the cleared meadow where it stands. Originally a loop of Diamond Mountain Road swung past the front door and vineyards surrounded the mountain residence. Known as Chateau Pacheteau, it was built for Jacques Pacheteau, owner of Pacheteau's Original Hot Springs, which still operates in Calistoga on the grounds of Brannan's Resort of the 1860s. The design of the structure follows the lines of church architecture.

The C.D. Mooney House (1875), 1105 Bale Lane, appears to have been built in two stages, as were many of the early homestead houses. The one story cottage was built first and then with more time, and prosperity, the more formal two-story wing was added. The wing carries the characteristic gable roof with a return in the Greek Revival style. The frame house has shiplap siding with contrasting trim about the double sash windows with their single upper and lower panes. The usual symmetry of the style is broken in front with only one window on the second floor.

Little is known about this small Queen Anne cottage (1895) at 1085 Dunaweal Lane, although some of its decorative features seem to carry the imprint of local builder A.D. Rogers of Calistoga. Rural dwellings are more often in the Greek Revival, Gothic Revival, or simple farmhouse styles and to find this cottage, which would be equally at home in Calistoga, in a rural setting is unusual. It carries the Queen Anne style features of a triangular pediment over the front bay, decorative fish scale shingles in the pediment and gablets of the hip roof, chambered corner windows, turned porch columns with their pierced and scrolled brackets, and a very fine carved front door with its screen door and transomed doorway.

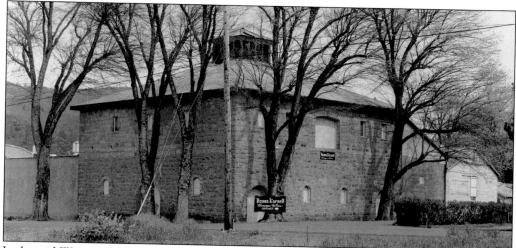

Larkmead Winery (1906), 1091 Larkmead Lane, now the Hanns Kornell Champagne Cellars, was one of many small cellars run by families in this viticultural region in the late-19th and early-20th centuries. The land on which the winery was built originally belonged to the unconventional Lillie Hitchcock Coit, well known to San Franciscans in the 1880s. In the early 1890s, the Salmina family acquired part of the vineyard estate. J. Baptist Salmina, from Switzerland, arrived in St. Helena in 1878. There he ran the William Tell Hotel until 1891. With his nephew, Felix, he started Larkmead Winery in a frame building. The present two story square stone winery was built c. 1906.

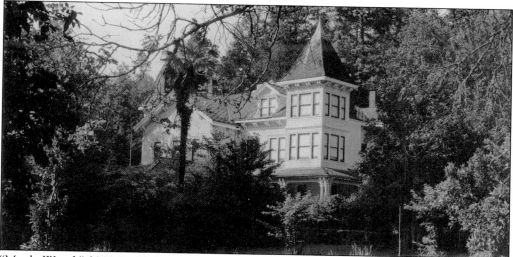

"Maple Wood," 3999 St. Helena Highway, was built as the country residence of Martin Holje, a San Francisco glue manufacturer, in the prevailing style of country villas of the late 19th century, in the Queen Anne style. Although the house was constructed in 1904, the Queen Anne influence lingered in Napa County well into the early 1900s. Martin Holje, a native of Germany, arrived in San Francisco in 1858. In 1876 he became a glue manufacturer; by 1900 his company was the largest on the West Coast. In 1900 he purchased 375 acres for stock raising, farming, and vineyards on Nash Creek. Part of the land had belonged to William Nash, one of the first pioneers to arrive in Napa County in 1846. The William Nash House still stands adjacent to the Holje House.

Pioneer William H. Nash, a horticulturalist who was to later plant many of the first fruit and nut trees in the Upper Napa Valley, arrived in 1846 in the first wave of settlers to establish themselves in the northern part of the Valley. He settled at Nash Creek. While living in a log house, Nash built the present two-story redwood frame house at 3999 St. Helena Highway North. The house, with shiplap siding, has a hipped and gabled roof with the roof extending out over a two-story veranda running the length of the front of the house. Simple square columns support the veranda.

The Oat Hill Mine Road, near the intersection of Lincoln and the Silverado Trail, was built in 1893 and served as a supply route between the isolated quicksilver (mercury) mines in the Twin Peaks, Oat Hill, and Kidd Canyon area and Calistoga. Quicksilver mining, a major economy in northern Napa County and Lake County, began in the 1850s and continued into the early-20th century. The Oat Hill, Aetna, Twin Peaks, Corona, and other mines in the region are still evident though no longer active. The Oat Hill Mine Road was built by men primarily employed by the mines with Supt. B.M. Newcomb of the Oat Hill Mine and J.L. Priest in charge. The road, cut through rock in many places, follows the original roadbed through rugged terrain. William Spiers, well-known Calistoga stagecoach driver, used the road on occasion to get to Aetna Springs resort although the route was never intended for coaches. In 1894, the property owners petitioned the county to take over maintenance of the privately built road. Today the road is a popular hiking trail between Robert Louis Stevenson Park and Calistoga.

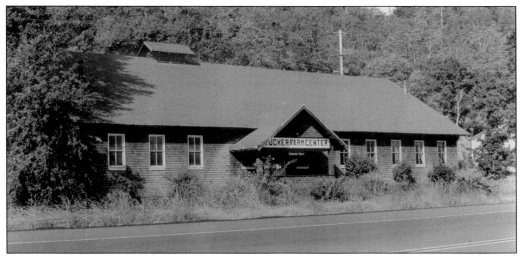

Agricultural Napa County was the fifth county in California to establish a Farm Bureau in 1914 and under Napa County Farm Advisor Herman J. Baade many farm centers were built by local organizations of farmers throughout the county. The Farm Centers, educational and social centers for the rural farm districts, sponsored community development programs such as road building, school rebuilding, installation of power lines, maintenance of levees and drainage, rural fire departments, etc. The Tucker Farm Center (1920) of Calistoga, located on the land of the pioneer Tucker family who had settled in the district south of Calistoga in the mid-1800s, is typical of the functional farm center buildings.

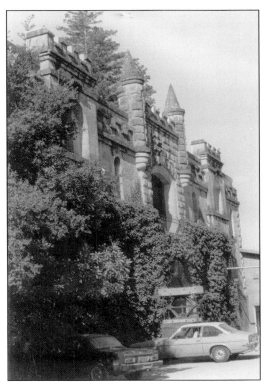

In the tradition of beautifully crafted wineries erected in Napa County in the 1880s on the country estates of prominent San Franciscans, Chateau Montelena, 1429 Tubbs Lane, was built for Alfred A. Tubbs, founder of the Tubbs Cordage Company in San Francisco in the mid-19th century. In later years he would become a California state senator. On his travels to France in the early 1880s he commissioned a French architect to draw plans for the winery and returned with French masons to construct it. Its facade is of imported cut stone and native stone was used for the rear and sides. The two-story winery is built into a hillside as was common to the period. The Chateau influence is evident in the facade with its battlements and stone turrets flanking the central arched doorways on the first and second floors.

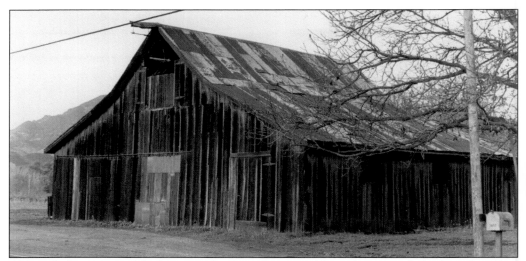

Although the earliest of the barns on the Cyrus homestead have disappeared, this barn (1900) at 2650 Foothill Boulevard across from 2653 Foothill, recalls the ranch of the Cyruses, one of the first settler families to arrive in 1846. Enoch Cyrus established his homestead at the end of the chain of settler families following the old Geyser Highway from the Bale Mill northward. Descendants of the Cyrus family still live on the original homestead property although the barn is no longer part of the property. The land surrounding the barn remains open land with scattered buildings. Typical of many barns still standing, the barn is frame with vertical plank siding with a gable roof extended to cover side bays. A tin roof covers the one and one-half-story barn. Immediately adjacent to the barn now is an orchard and the road passes very close to the structure.

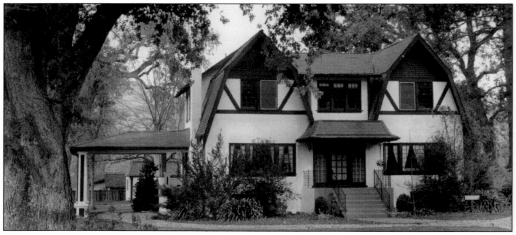

The picturesque cottages of England, Europe, and early Colonial America were a popular in-spiration for the Revival styles common to the 1920s and 1930s as seen in this house built for Dr. Henry Pond on his retirement to Calistoga. The house, 2412 Foothill Boulevard, draws on the popular gambrel roof of the early Colonial period and the stucco and stick work detailing of English Tudor cottages. Note also the multi-light sash and casement windows. A carport juts to one side. The grove of trees surrounding the house has been a local landmark for many years. Surrounding the residence is a mobile home park on what was once a prune orchard. Well into the early 1900s, the grove and the land behind it was used for encampment space when Native Americans from Lake County would return to the area for the prune harvest.

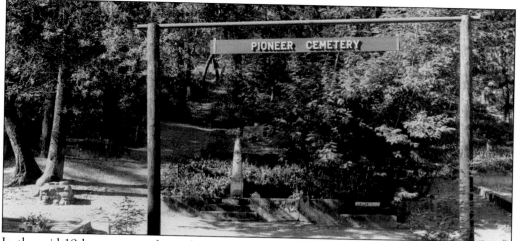

In the mid-19th century as the early settler families moved into the county, burials were most often in small family plots on the ranches. It was not until 1894 that the first public cemetery was opened, although in the early 1870s a cemetery on the Lake County Highway just beyond the Oat Hill Mine Road turn-off was used for this purpose. S.W. Collins, whose property included the site of the Pioneer Cemetery on Foothill Boulevard, established the cemetery at the turn of the century. His daughter, Mrs. Annie Hopper, gave the cemetery site to the city in 1936. Many headstones from small family cemeteries have been transferred to the Pioneer Cemetery, giving a unique visual record of the early families of the upper Napa Valley.

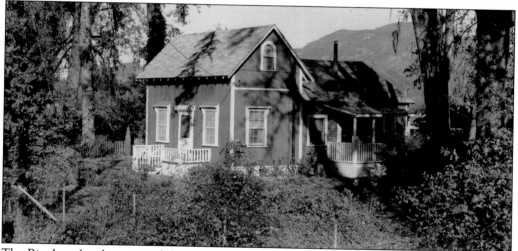

The Bingham brothers owned this diminutive cottage at 512 Foothill Boulevard at the edge of the Calistoga city limits, and lived there well into the 1930s. A Victorian Gothic influence is seen in the one and one-half-story cottage in the shelf window hoods over the double-hung sash windows with their six-over-six panes. The brothers, both bachelors, shared the cottage, which is only one room wide and two rooms long. Vertical boards form the siding. Note the semi-circular arched window in the gable end. A one-story addition to the rear appears to be early and it has shiplap siding. Such owner built cottages were common in the 19th century and most have disappeared. Square posts support the side porch. Curiously, the front door does not have a covering porch but note the decorative hood over the door sawn in a dentil motif. The cottage is now in a grove of trees at the bottom of the embankment of the highway.

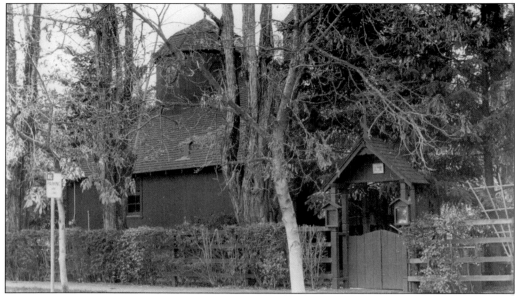

The presence of a large Russian community in Calistoga made possible the construction of this church for the Holy Assumption convent. The church at 1519 Washington Street, constructed as a replica of the Orthodox Church built at Fort Ross in 1828, was built in the 1940s. It is frame with vertical plank siding and the unusual domical roof. Fort Ross, the southernmost of the Russian fur trading centers, was established in 1812 to open trade with Spanish California. The Holy Assumption Orthodox Church, one of two Orthodox churches in Calistoga, is a reminder of the early Russian presence in California and the ethnic diversity of Napa County today.

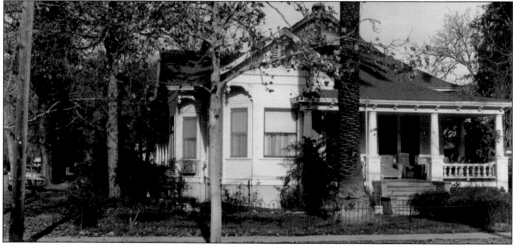

The Walsh House, 1314 Washington Street, Calistoga, constructed at the turn of the century, reflects the Queen Anne influence of the late-19th century and the Colonial Revival influence of the early-20th century. The narrow siding of the one-story frame house is of this transitional period; the carved corner brackets with their drop pendants, the slanted bay window, and the fish-scale shingles in the gable ends are Queen Anne motifs; the wide veranda with its Doric columns are the Colonial Revival periods. Note the turned balusters of the porch railing and the brackets supporting the porch eaves, which are flattened and a decorative element.

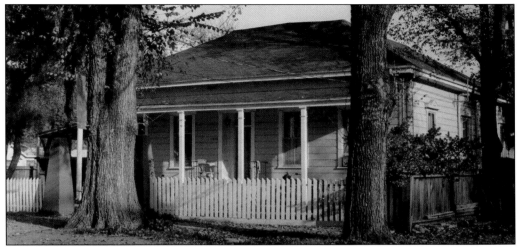

On the property between First and Second Streets, which originally belonged to Morris Fried-berg in the 19th century and later became Piner's Hot Springs, stands this large one story hip roof cottage, unique for its unusual and decorative window hoods. Although the front porch, added at a later date, now hides the elaborate squeezed pediments over each window, they may be seen on the windows to the side. Such window treatments are commonly found on larger and more formal buildings. The recessed and paneled entry way with its transomed doorway is also a significant feature. Morris Friedburg and Henry Gettleson built the first general merchandise store in Calistoga at Washington and Lincoln in 1866.

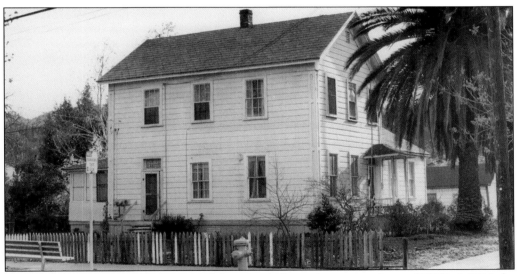

Little is known of the early history of this straightforward two-story house (1880), 1438 Lake Street, which carries a gable roof and central chimney and faces gable end to the street in the Greek Revival manner. Its size and scale is unusually large for a frame house in Calistoga. Siding is shiplap and the only surface decoration is in the corner boards. Windows have double-sash with two-over-two or six-over-six lights. The symmetrical placing of the windows and transomed door-ways is also characteristic of the Greek Revival style. Note the large palm tree in front. James G. Finch, originally from England, served as superintendent of the Oat Hill Mine. When the mine closed in the early 1900s he remained in Calistoga, becoming city clerk in the 1920s.

The bungalow, synonymous with the West, was introduced to California in the 1890s and reached a height of popularity in the 1910s and 1920s when plans for versions such as this California bungalow were easily obtained from plan books and copied by local builders. This excellent example of the California bungalow at 1402 Lake Street carries the characteristic features of the style: one story in height with a gently pitched broad gable, extended and exposed rafters, a broad veranda in front and wrapping around the side, supported by battered piers, and a double gable in front. The low horizontal quality is particularly a feature of the California bungalow, as is the stucco finish. Note also the horizontal bands of windows with multi-paned upper sash. Although stripped down versions of bungalows were often used in early 20th century tract developments, often older neighborhoods such as this one will have individual residences exhibiting a high degree of craftsmanship.

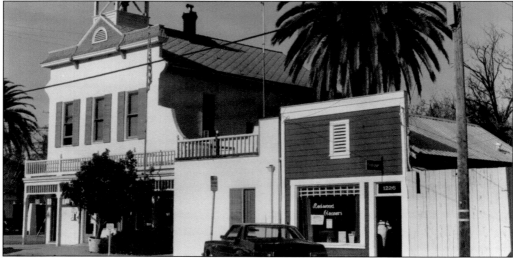

Calistoga's City Hall, 1232–1234 Washington Street, was built on the site of Badlams Opera House, which had served Calistoga as a public hall prior to the fire of 1901. The City Hall replaced the earlier town hall, which had been located in the late-19th century first at the corner of Washington and Gerard and then on Lincoln Avenue. As did most of the buildings on Lincoln Avenue, the town hall burned in the devastating fire of 1901. In the rebuilding of the commercial section of town that followed, many buildings picked up the Mission Revival influences of the period.

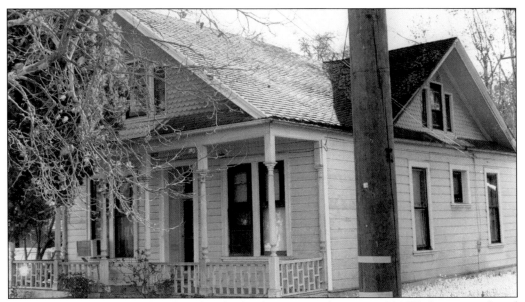

The Palladian style of window found in the Iaacheri-Vermeil House at 911 Washington is found in few buildings in Calistoga. The house is a variation of the Queen Anne cottage popular in the 1880s with its pedimented-boxed cornices, multi-gabled roof, fish-scale shingles, and stained glass panes in the upper sashes of the windows. Note also the door with its transom and the porch with its Eastlake columns. An early addition to the Iaacheri-Vermeil House was a part of a cabin built by Henry Fowler, a Calistoga pioneer.

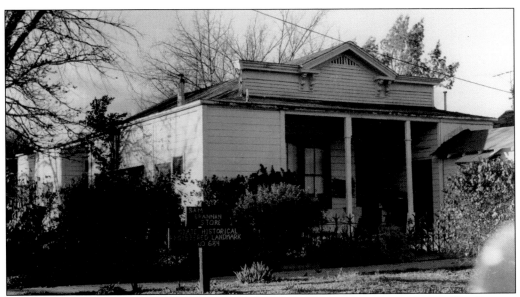

The Sam Brannan Store (1862) at 302 Wapoo was once central to the Calistoga Hot Springs resort of Sam Brannan, which marked the beginning of the hot springs resort era in Calistoga. It is one of only two resort structures remaining on their original sites. The false front with its squeezed pediment and supporting scrolled and paired brackets has clapboard siding and projects over the recessed entryway.

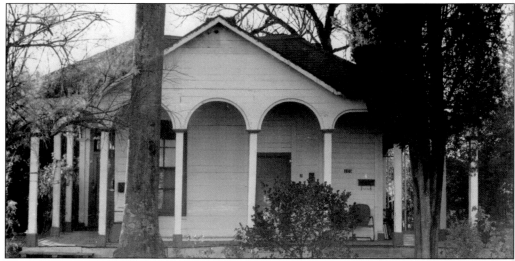

This cottage at 109 Wapoo, in the 1870s, a part of the Sam Brannan Calistoga Hot Springs Resort, is the only resort cottage remaining on its original site. The Wapoo Cottage differs from many of the original 25 resort cottages in that it has a gable roof over the front wrap-around porch and a different interior floor plan. The semi-circular arches of the Wapoo Cottage are similar to those of the other cottages but lack the decorative trim. A large palm and cypress tree are at the entrance. Wapoo Avenue formed part of the inner circle of the resort complex. The 25 cottages lined along the inner avenues faced the resort hotel. The casual visitor used some of the cottages; families who visited frequently owned others. Adjoining the resort area were 40 acres of racetrack and stables.

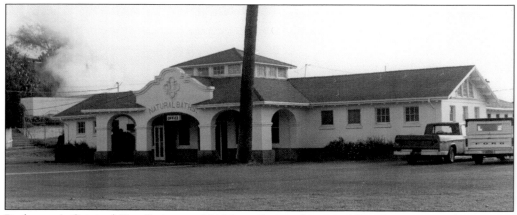

Pacheteau's Original Hot Springs at 1712 Lincoln, on the site of Sam Brannan's Calistoga Hot Springs, was built about 1912–1920, continuing the strong spa tradition in Calistoga to this day. The Bath House/Office (for the Hot Springs) is in this Mission Revival building, which beautifully illustrates the characteristic curvilinear gable, arcade, broad gabled roof, and plain wall surfaces and plain impost molding on the arcade piers. Steam from the hot springs rises behind the building. Jacques Pacheteau leased the Hot Springs grounds about 1911 from the Leland Stanford estate. Stanford had acquired the property in 1875 when Brannan went bankrupt and lost all his Calistoga property. In 1919 Stanford finally sold the property. Jacques Pacheteau, a well-known wine merchant, had his own vineyards on Diamond Mountain, near his residence known today as "Pacheteau's Castle."

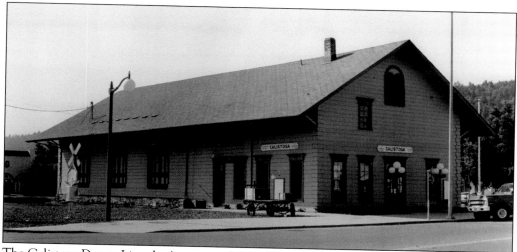

The Calistoga Depot, Lincoln Avenue and Fair Way, is believed to be the oldest surviving railroad depot in California. In 1868, one year prior to the completion of the transcontinental railroad, Napa County passed legislation authorizing the extension of the Napa Valley Railroad to its northern terminus in Calistoga. It greatly benefited Sam Brannan, but also had great impact upon the County in hastening settlement and agricultural development. The Central Pacific Railroad absorbed the local railroad in 1871 and the Southern Pacific took over the line a few years later. The large utilitarian structure is unlike any depot of the period. Of wood with shiplap siding, decorative detailing includes quoins and a plain molding surrounding windows and doors. The structure is essentially unchanged with the exception of the removal of the original cornices over the north end doors and windows prior to 1940 and some alterations to a door and window. In recent renovation, the loading platform was removed.

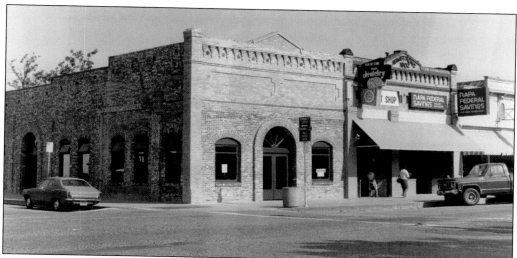

The Armstrong Building at the intersection of Washington and Lincoln is a focal point of Calistoga's commercial district and is a very fine example of commercial architecture of the turn of the century in brick. The structure is essentially one building with a double facade and central dividing wall. Charles W. Armstrong, the original owner, had his drugstore in the northern half and there was a grocery store in the southern hall. A decorative pendant-like brick pattern and triangular pediments distinguish the cornice.

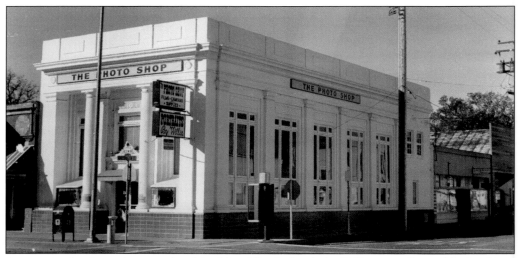

Appropriately, the only example of the Neo-Classical style in Calistoga so favored by banking, commerce, and transportation centers is the Bank of America building. It is distinguished on a simple scale by its portico with massive Doric columns flanked by equally massive pilasters, the smooth wall surface, and raised ground story are characteristic of the popular early-20th century style. In 1961, the Bank of America moved to another location. Subsequently, the building was used as a photo finishing plant. The building's location on the corner of Lincoln and Washington Streets make it a focal point of the commercial district.

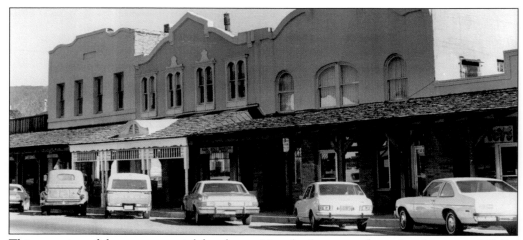

This grouping of three commercial facades on Lincoln Avenue reflects the character of Calistoga's early-20th century commercial streetscape as seen in the second stories of the buildings. The curvilinear gables of the roofline suggest the Mission Revival influence of the early-20th century. Disastrous fires in 1901 and 1907 resulted in rebuilding in this particular current and popular style. Although the street level storefronts have been remodeled over the years, the upper floors have retained their character. Note the stone commercial building to the north, which apparently survived the fires but was modernized with a stucco facade and curvilinear gable (1362–64 Lincoln). The central building (1356–60 Lincoln) with the *Weekly Calistogan* office has been recently renovated; note the unusual window hoods and arched window trim. The former movie theatre (1350–54 Lincoln) has fine semi-circular arched windows with a central semi-elliptical window.

Traces of the early character of this 19th century, Romanesque Revival, two-story commercial brick building at 1343 Lincoln remain in the plaster cast and pressed brick embellishments in a flower and vine motif along the cornice and in the molded arch trim of the second story windows. Note particularly the twin double hung arched windows. The Oddfellows Hall was built in 1887 when fraternal organizations in the county were at a peak of stability and popularity. The prominent location on Lincoln Avenue with the Masonic Lodge just across the street was a pattern repeated on countless other Main Streets. The brick kiln supplying the brick for the building was located two miles south of Calistoga. Ed Power and Homer Hurst, both local men, made the bricks. A local mason, Madden, erected the hall. The 1906 earthquake damaged the building and it was necessary to install tie-rods for reinforcing, which Henry Brown did.

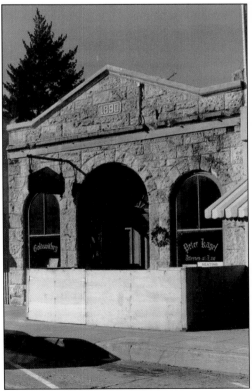

The C.A. Stevens Bank at 1339 Lincoln, a one-story, Romanesque Revival, stone commercial building, is as solid and substantial as Calistoga's first bank should be. The building is of locally quarried cut stone and shares a common wall with the I.O.O.F. building. A squeezed pediment of cut stone with a dated panel "1890" forms a false front. Semi-circular arched windows flank a semi-circular arched recessed doorway. Of particular interest is the curved transom window with spokes over the door and the stone vault inside which contains the original safe made in 1880 by the Webb Safe Company of Portland, Oregon. Competition with a second bank in Calistoga in 1897 encouraged Stevens to include a stock of men's furnishings in the bank to draw customers. After Stevens' death, C.A. Carroll, publisher of the *Weekly Calistogan*, purchased the building and it remained the office of the newspaper until the 1970s.

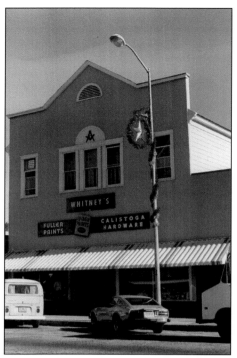

The Masonic Lodge (1905) at 1334–1336 Lincoln was one of several fraternal lodges that played an important role in the social and economic life of 19th century Calistoga. The Masons constructed this frame false-front building soon after the devastating fire of 1901 destroyed an earlier hall along with most of the Lincoln Avenue commercial district. The Masonic Hall, two stories and rectangular with shiplap siding, has a distinctive false front with a squeezed pediment concealing the gable roof. On the first floor there was originally one large room for dances, theatricals, and even basketball games.

The Brannan Stables (1859) at 1506 Grant were built to shelter the racehorses of such guests to the Hot Springs as Hopkins, Lick, Hearst, and Stanford, served the racetrack adjoining the resort grounds. Brannan went bankrupt in the 1870s and the resort changed owners several times with Ephraim Light purchasing the stables c. 1915 and converting them to a winery. The building remained in the family until 1959. Subsequently, a well drilled near the famed Light Geyser yielded mineral water suitable for bottling, which is continuing today in the old stables. The Brannan Stables stands as perhaps the largest industrial building in Calistoga.

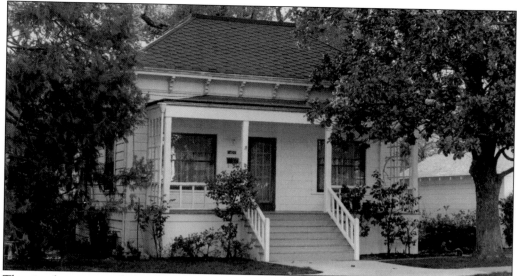

The simple one-story hip roof frame cottage, 1401 Washington, was a popular style of the late-19th century in Napa County. The Largey-Light House, with its shiplap siding and pierced scrolled brackets supporting the eaves, is typical of such cottages. The raised front porch is also found throughout Calistoga where flooding was common. At one time, there was probably cresting along the ridgeline of the roof, which has been removed and the front windows have been altered. Edward Largey was a brakeman with the Southern Pacific Railroad when he took up residence here c. 1893.

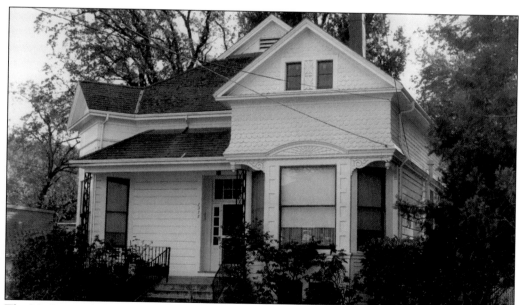

The McGreane-Frank House (1887), 1317 Washington, a Queen Anne one and one-half- story house, was constructed by local craftsman-builder A.D. Rogers for the Frank family. Local redwood was used and Rogers picked up the popular Queen Anne elements of pedimented and projecting dormer, three-sided slanted and rectangular bay windows, and horizontal bands of octagonal and fish-scale shingles.

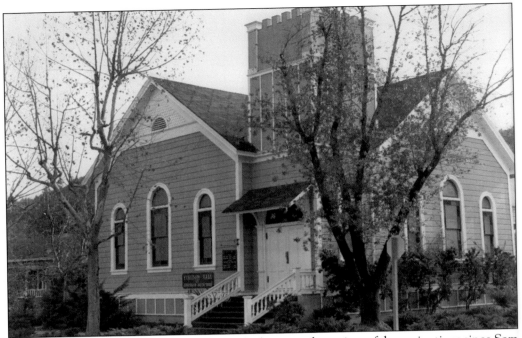

The church on the corner of Spring and Cedar has served a variety of denominations since Sam Brannan gave the lot to the Methodist-Episcopal denomination. The one-room frame church was built in 1869. In 1902, the local contractor, C.J.B. Moore, extensively remodeled the church and it took on its present Victorian Gothic appearance. The bracketed portico resting on pilasters on each side of the double door and the staircase with its spindle balustrade also date from the 1902 renovation. In 1946, the Methodists joined the Presbyterians in forming the Calistoga Federated Church, now the Calistoga Community Church at Third and Washington.

The Ayer House at 1139 Lincoln is a fine example of the Italianate style in Calistoga. It demonstrates the hip roof, double brackets supporting the eaves, and two-story polygonal bay window associated with the formal Italianate style but translated on a smaller scale. Charles A. Ayer had a dairy farm in Illinois. In 1868, he visited Calistoga and contracted with Sam Brannan to supply dairy products to Brannan's Hot Springs Resort. In 1872, Ayer gave up his Calistoga dairy and became station agent for the railroad and also agent for Wells Fargo.

The Culver House (1875) at 1805 Foothill is rather unusual in Napa County, for the jerkinhead or clipped gable roof is uncommon. The central clipped gable is a variation of the Gothic Revival style and at one time there may have been decorative trim along the eaves, for there is still a finial at one gable end. Note the tall, narrow windows with their double hung sash in the central peak and gable end. Both the single window in the peak and the pair in the gable end have segmental arches and plain arched molding. Balusters of the raised front porch are finely turned. Like most of the houses in Calistoga, the Culver House has shiplap siding.

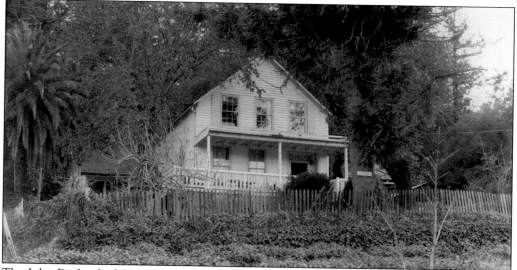

The John Rutherford House (1875) at 1423 Foothill combined two early and now rarely seen exterior sidings in Napa County: board and batten and clapboard. Most buildings from the 1870s on used shiplap siding. This small one and one-half-story Greek Revival House has the characteristic gable end to the street and it is sheathed in clapboard. The sides of the house are of board and batten. Windows are double sash with six-over-six lights and are placed symmetrically with the door to one side. The door no longer has its transom window. John R. Rutherford, a rancher, resided here in the early 1900s.

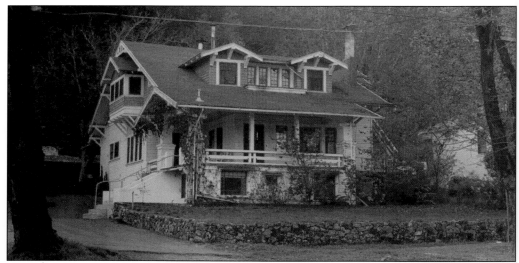

Chaunce E. Ingalls purchased this fine Craftsman style house (1910), 1213 Foothill in the early 1920s. Ingalls, who had worked for Hercules Powder, was an inventor and had patented an improvement for dynamite. The residence on the sloping hillside above Foothill Blvd. and Lincoln commands a prominent view overlooking Calistoga. The largest of the Craftsman style houses built in Calistoga in the early 1900s, the house also displays features of the bungalow style popular in the same period. The one and one-half-story house with a raised foundation in front has a steeply pitched gable roof, which extends over the front veranda. Massive square piers support the roof in front. Smaller gables are visible over the dormer windows in front and to the sides. The characteristic exposed stick-like purlins and struts are emphasized. Narrow, horizontal wood siding is on the first level with shingles on the second.

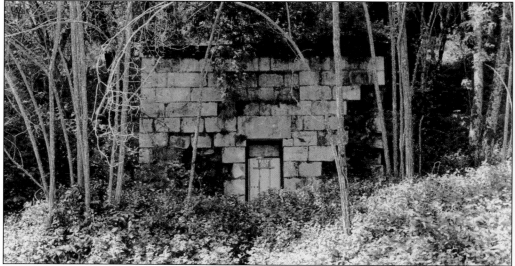

Samuel Brannan dedicated the land surrounding Winans Vault on Foothill Boulevard (west of Lincoln) for a family burial plot. Only the vault was built. It is of stone brought from China by Joseph W. Winans, husband of Brannan's niece, Sarah Badlam. Sam Brannan plummeted from being a millionaire to dying penniless in 1889 in San Diego. Don Francisco, a son who died before his third birthday, was buried in the vault, but has since been removed to St. Helena cemetery.

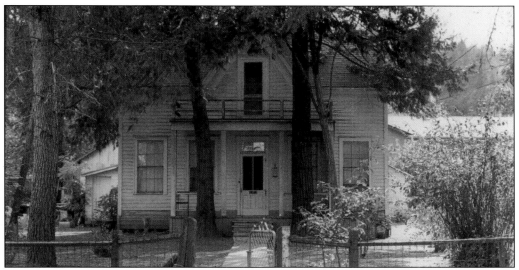

Gothic Revival cottages similar to the Lillie House (1870) at 1413 Cedar are found throughout Napa County but few are in as unaltered condition as this cottage in Calistoga. The Lillie House, a one and one-half story redwood frame building with clapboard siding and a characteristic center gable, is of a simple design originally prompted by Andrew Jackson Downing in his 1853 pattern book, *The Architecture of Country Houses*. Leonard G. Lillie, a millwright, arrived in the county in 1850. He built the overshot wheel for the Bale Mill and in 1854 became the first owner of the White Sulphur Springs resort in St. Helena. His son, George Lillie, was a surveyor with the Napa Valley Railroad, which arrived in Calistoga in 1868.

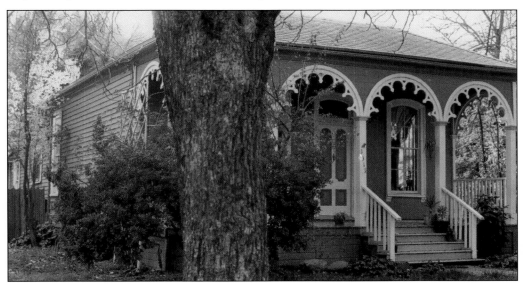

This Brannan Cottage at 1311 Cedar Street is a well-preserved example of the cottages that predominated the Calistoga Hot Springs grounds in 1862. Tom C. Brown in 1876 moved this cottage to Cedar Street. Over the years the interior has been remodeled but note the low-hipped roof and porch with its arches and decorative trim, and the windows and transomed door with segmental arches and the horizontal clapboard siding. The cottages all carried names; this one is called Brannan's Folly.

Significant in the Shafer House (1875), 1018 Cedar, are the false-front wings, which are found in only three residences in Calistoga. A one-story frame house with shiplap siding and a gable roof, the Shafer House was built by David C. Willis. Willis had migrated from New York to Missouri to Calistoga in 1874. He owned a saloon on Lincoln Avenue and a half block on Cedar Street, which he gradually sold off in lots. A well still exists on the lot adjoining the house. In 1936, the Shafer family purchased the house.

Four

RURAL RETREATS

The McClure House (1870), 2874 Las Amigas Road, at the Duhig intersection in the Carneros District, is two stories with a projecting bay window in front. Eaves of the bay window and front porch are ornamented by a notched bargeboard, with a half-inch circle drilled through the center of the points between notches. A wooden five-pointed star in circle ornaments the center of the front gable. A one-story section attached to the rear is older than the two-story house, being part of the original house on the property. In 1928 a cement foundation under the two-story house replaced the original redwood block foundation.

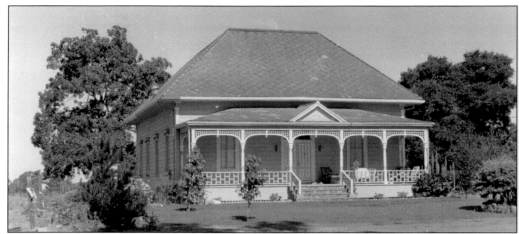

This early ranch house (1855), 669 H Napa-Vallejo Highway, appears to be the only residence remaining in the once thriving Suscol, a transportation center of the 1860s, clustered around the intersection of the Suscol Ferry Road and the main north-south route (today's Hwy. 29). Just south of Soscol Creek on land originally owned by Mariano Vallejo in the 1850s, the house is used as a landmark reference in deeds of the period. Samuel McDonough is mentioned living in a "farmhouse" at the site in 1856. The Devlin family acquired the land surrounding the ranch house in 1910. By then the house had taken on its present appearance, which the Carrolls restored in 1974. The frame house is only one story in height with an unusually steep hip roof. Originally, the central double doors opened into a central hallway extending from the front to the rear of the house. Doorways opening off the hall are transomed. Apparently, c. 1885 the front porch was added with its latticework, turned columns, and balustrade.

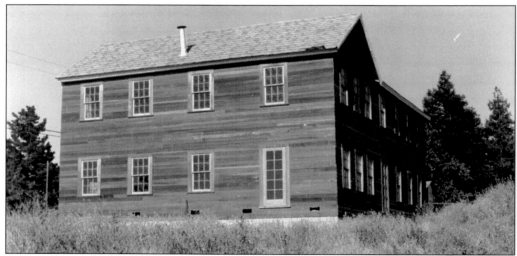

The Soscol House (1856) on Soscol Ferry Road is the earliest remaining example in Napa County of the once common stage stop inn of the mid-19th century and is the only commercial structure remaining of the once thriving Suscol. Suscol served as a transfer point for stage lines serving Sacramento, Suisun, Napa City, Petaluma, and Sonoma. San Francisco steamers docked at Suscol Wharf; the Napa Ferry crossed here; the Napa Valley Railroad made connections at Suscol and it was the shipping point for Napa County products to San Francisco prior to the rise of Napa City in the 1870s.

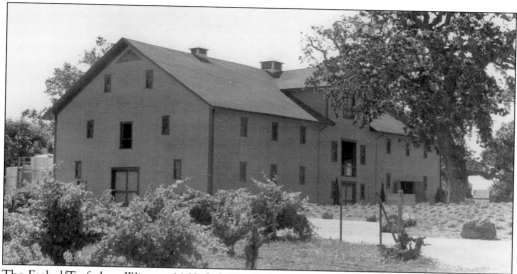

The Eschol/Trefethen Winery, 1160 Oak Knoll Avenue, is unique for it is the only remaining example of a 19th century, three-level gravity flow winery constructed entirely of wood in Napa County and was designed by the leading architect of the period in California, Capt. Hamden W. McIntyre. Of redwood with shiplap siding, the central core of the winery is two and one-half stories with flanking two-story wings. Crushing took place on the top level with pressing and fermenting on the second level and storage on the ground. There are doors at each level at the gable ends and in the central core on both sides. Unlike most gravity flow wineries, which were built into a hillside, Eschol/Trefethen Winery was on level ground and an elevator was used to haul grapes to the crushing floor. The Winery has essentially retained its original design features, although structural supports have been added to the interior and the ventilation shafts in the roof have been altered. Vineyards surround the winery as they did in 1886 when James and George Goodman, founders of the Goodman Bank, the first bank in Napa, had the winery built on their Eschol Ranch. The Trefethen family purchased it in 1968.

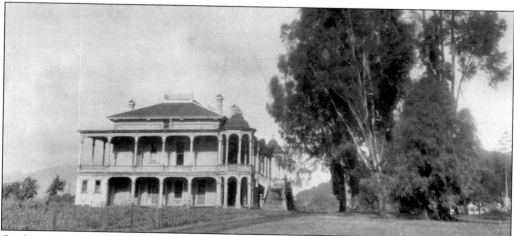

On June 23, 1870, Gottlieb Groezinger, born in Wurttenburg, Germany, 1824, acquired title to 370 acres of land west of Yountville. By 1872 he had constructed this baronial mansion, two floors in height, with a lily pond in front, and a spouting fountain in the center and a rose garden surrounding it.

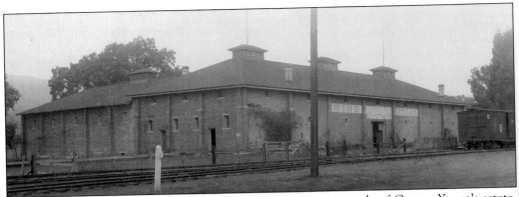

In October 1870, Groezinger purchased from the court auction sale of George Yount's estate, one square block known as the "Public Square" in Yountville, and a wedge-shaped piece of property south of Madison Street, for $250. His addition to the Town of Yountville added 10 blocks, extended four existing streets, and added three more streets. He reserved one triangular block in his addition for the use of the public park. When Groezinger left Yountville in 1889, he left behind the Groezinger Wine Cellar complex now known as "Vintage 1870."

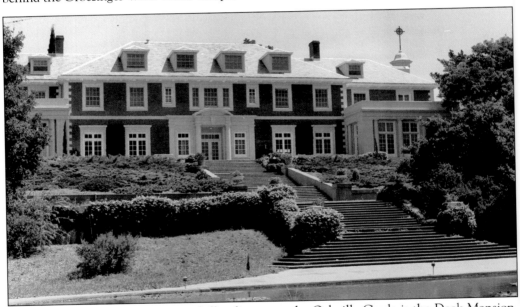

Situated on a knoll in the western hills adjacent to the Oakville Grade is the Doak Mansion, built by the wealthy San Francisco industrialist David Perry Doak as his country estate in 1918. Since the mid-19th century, prominent San Franciscans have had their country and vineyard estates in Napa County and continue to do so today. The Doak Mansion appears much like a movie set (which it has been in recent years), within its setting of formal gardens and pools designed by John McLaren, responsible for the design of Golden Gate Park. Colonial Revival in style, the Georgian influence is most evident in the symmetrical composition of the two and one-half-story brick building. The low hip roof with dormers is characteristic as is the pedimented entryway with its massive columns. Double hung sash windows on the second floor have 16 lights; there is a tripart window over the entryway. One-story wings to each side are original. In recent years the Carmelite Fathers acquired the mansion from the Stelling Estate and added a chapel to the east, which is visible from Highway 29.

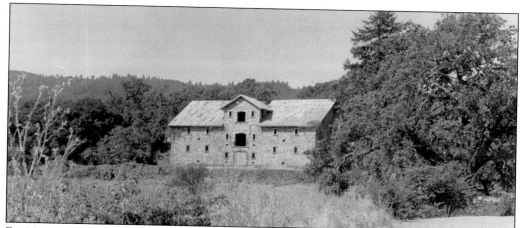

Far Niente Winery, 1577 Oakville Grade, designed for John Benson in 1885, is believed to be the earliest of the stone three-level gravity flow wineries designed by Hamden W. McIntyre, acknowledged as the finest winery architect in 19th-century California. Trained as an engineer, McIntyre had designed for Leland Stanford the brick and wood Vina Winery in Tehama County in 1884. Apparently Far Niente was his first stone winery and the prototype for several innovations he would introduce into the design of future gravity flow wineries throughout California. The winery, of native fieldstone, backs into the terraced hillside giving access to all three levels. Two two-story wings flank the three-story central core. Crushing took place on the top level, fermenting on the second level, and storage on the ground floor. Windows are rectangular with cut stone sills and lintels. Segmental arched doorways and corners have cut stone quoins. Interior woodwork is of tongue-and-groove redwood. In 1953 a central cupola in the gable roof was damaged and removed. John Benson, active in real estate and mining, lived primarily in San Francisco.

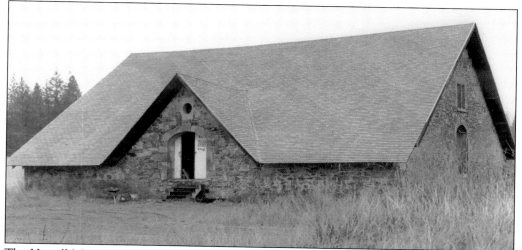

The Howell Mountain Nouveau Medoc Winery (1886) at 150 White Cottage Road in Angwin, constructed during the height of the viticultural period of the 1880s, is an excellent example of the three-story gravity flow winery, which was common to the period. Of local uncoursed fieldstone, the winery is distinguished by a broad gable roof with a projecting, steeply pitched gable roof over the third story entrance, an unusual design feature. The segmental arched doorways on at all three levels have radiating cut stone detailing with a center keystone and quoins. (cont. 110)

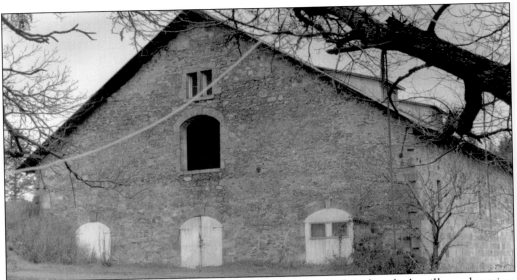

The rectangular windows are also detailed in cut stone with plain lintels, lugsills, and quoins. Brun and Chaix, founders of Nouveau Medoc, were from France. Brun was experienced in making olive oil, cider, and wine. Chaix was a horticulturalist. In 1877 they bought the vineyard on Howell Mountain, and in Oakville, close to the railroad, they built their first cellar. By 1881, their wines were going to New Orleans, New York, and New Jersey.

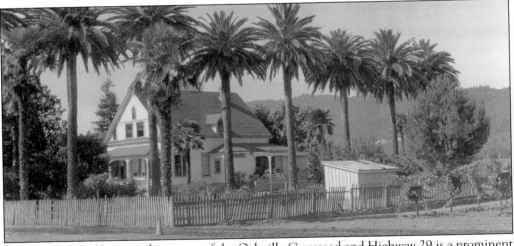

The Sehabiague House at the corner of the Oakville Crossroad and Highway 29 is a prominent landmark in Oakville where its columns of palms stand out on the horizon. Built in 1894 as the residence for the Sehabiague family, it was conveniently near Brun and Chaix's Nouveau Medoc Winery in Oakville, where the senior Sehabiague was winemaker for Brun and Chaix. The winery once stood adjacent to the railroad tracks, as do many of the Napa Valley wineries still. The Napa Wine Company is located here today. The house is transitional in character with the strong pedimented gable reflecting the Queen Anne period but the steeply slanting gable roof suggests the influence of the Shingle style. Note the horizontal band of windows in the gable with the windows adjacent to the eaves cut to conform to the shape. Windows are one-over-one sash. Note also the gabled dormer in this one and one-half story house. Siding is shiplap. Square columns support the front porch and there is a fine turned balustrade.

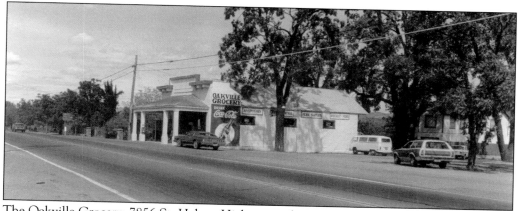

The Oakville Grocery, 7856 St. Helena Highway, today is very characteristic of the 1920s and 1930s commercial storefronts, even to the Coca-Cola sign on the side. Yet the store has served as grocery and post office to the Oakville community since the early 1900s when Frederick Durant and Willis Booth had their general merchandise store here under the name Durant & Booth. Essentially a false-front building, the stepped parapet conceals a gable roof. Note the suggestion of rafters supporting the front cornice. The storefront window is also characteristic with its large central panes and smaller vertical panes in a horizontal band at the top. Oakville, a center for many large vineyards and wineries, was also a stop on the railroad through the Napa Valley and the point of departure for travelers going over the western mountains into Sonoma County via the Oakville Grade.

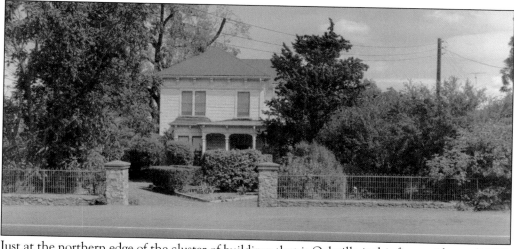

Just at the northern edge of the cluster of buildings that is Oakville is this fine residence (1890) at 7862 St. Helena Highway, which was the home of Frederick Durant at the turn of the century. Durant and Willis Booth ran for many years the general merchandise store, which is now the Oakville Grocery. Durant's house adjacent to the store is two stories, and L-shape in plan with a hip roof. The lines of the house are simple with shiplap siding and ornamentation suggesting the Stick style limited to the one-story straight bay window in front, the veranda curving around the side, and the scrolled and pierced brackets supporting the eaves. The cornice also carries a paneled frieze. Windows are double-hung with one-over-one sash. Surrounded by trees and shrubbery, the house has a low stonewall and gate posts in front. Oakville served as a railroad stop for the small resorts and quicksilver mines in the western hills and for the wine cellars in the region.

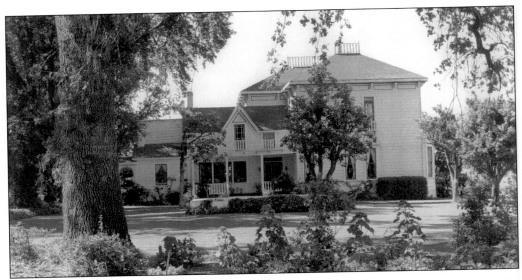

Rarely do we find an early settlement pattern so clearly defined as in the split personality of the H.W. Crabb House with its Gothic Revival original house and its Italianate "addition." With increased prosperity settler families often built a second larger house in the more formal styles currently in vogue much like today. The clapboard Gothic Revival house at Walnut Drive in Oakville has the characteristic central peak and door onto a second story veranda. The first floor windows and door have been altered. The Italianate addition, c. 1880, retains its design integrity. Note the hint of a tower over the entryway; the cornices of the roofline and first floor slanted bay windows and the recessed doorway. The half-round transom over the door is original; the doors have been altered. A brick wine cellar is under the original house and carries bricks initialed "H.W.C." H.W. Crabb, a well-known 19th-century viticulturalist originally from Ohio, experimented with grafted foreign varietals and had one of the largest vineyards in the county. Originally called Hermosa Vineyards, his wines later carried the name ToKalon, renowned throughout the country. Edward Churchill, prominent Napa banker, acquired the house and vineyards in later years.

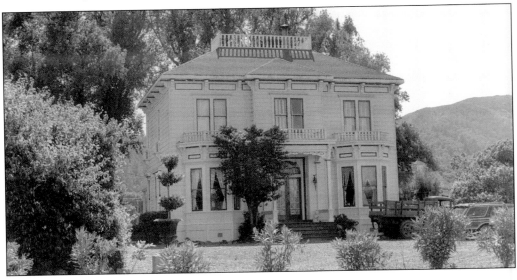

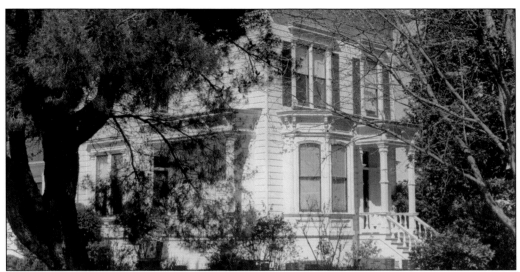

When C.P. Adamson built his residence at 8817 Conn Creek Road in the 1870s near Rutherford, a contemporary account described it as a "fine two-story house supplied with marble mantels, hot and cold water, and all the modern conveniences. It is representative of the country residences being built in the Italianate style, which gradually replaced the earlier Gothic farmhouses and cottages. Of wood, with shiplap siding, scrolled and pierced brackets support the wide eaves of the shallow hip roof. Balustrades originally capped the first floor bay window cornice, porch cornice in the front and side porch and were removed in the renovation of 1972. Note the transomed doorways and original front door and the turned spindles of the stair balustrade. The colonettes separating the segmented arched windows of the bay window and the shelf window hoods of the double-hung sash windows add interest." C.P. Adamson, born in Germany, arrived in California in 1854. In 1870, he purchased the farm on Conn Creek from the Yount Estate and developed extensive wheat fields and orchards. The house passed into the Cole family and was then acquired by Barbara and Richard Howell in 1972.

Hamden McIntyre, the most widely acclaimed winery architect in 19th-century California, designed the stone winery at 1960 St. Helena Highway, that is now the core of Beaulieu Winery, for State Senator Seneca Ewer in 1885. It was one of the earliest stone wineries designed by McIntyre. The Ewer Winery is now flanked by early-20th century additions to the north and south. The two and one-half story building has segmental arched doorways in the gable end of cut stone, as are the quoins. Windows are rectangular with plain cut stone lintels and sills. In 1915, Georges de Latour, who had established his vineyard estate, "Beaulieu" near Rutherford, bought the Ewer Winery, and enlarged it. The two and one-half story Mission Revival addition to the north is of this period and has the characteristic stucco walls, semi-circular arched windows and doorways, tower, and tile roof.

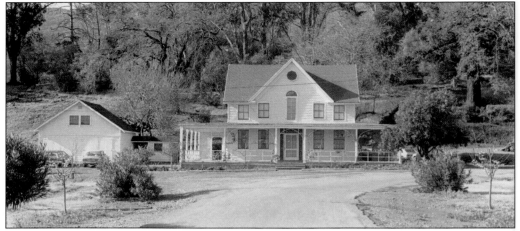

Inglenook (1875) at 1991 St. Helena Highway, the estate of W.C. Watson in the 1870s, was known for its mineral springs and was operated as a spa. This small, clapboard, one and one-half-story Gothic Revival cottage reflects the simple life of the early estate and the cottages prevalent in the rural areas of the county at that time. The first floor appears unaltered with its double hung sash windows with their 12 panes and the original doorway with its side panels and transom over the door. The second story front windows appear to have been added at a later date.

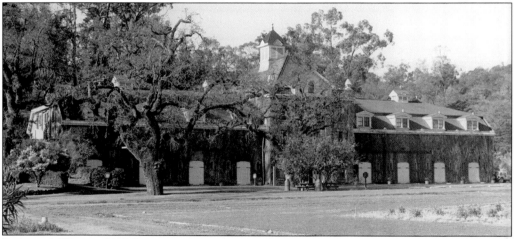

Inglenook Winery (1885) at 1991 St. Helena Highway, erected during the viticultural boom of the 1880s in Napa County, was to establish a standard of excellence for its wines in international competition. It employed the most advanced building technology of the period and exacted the most stringent cleanliness in the winemaking process. A contemporary described the winery and cellar that Capt. Gustave Niebaum erected at Inglenook in 1889 as "semi-Gothic and Eastlake in design." Of gray and brown stone quarried on the property, the three-story winery was built into the hillside. Iron pillars and reinforcement were used; concrete floors were laid throughout. The axis of the winery is three stories with wings extending 62 feet on each side. A semi-circular stone arch marks the main entrance. A triangular pediment enclosing a semi-circular arched window is two stories above the main entry. Note the cupola with its squeezed pediment trim above the central hip roof. The building, of gray stone, is accented in brown stone. The original tasting room inside the main entrance remains unaltered. Captain Niebaum, born in Finland, made his fortune in the Alaska fur trade.

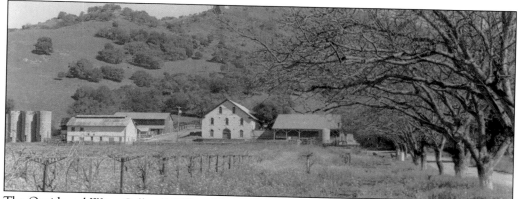

The Occidental Wine Cellar (1878) at 5584 Silverado Trail is one of the earliest examples of the three-story stone gravity flow winery, which became the prototype of Napa County wineries in the late-19th century. The largest winery of its period, it marked a movement to construct larger wine aging facilities. The lack of such aging cellars had held back the wine industry in California. The Occidental Wine Cellar was constructed of native stone quarried near Napa Soda Springs. Of cut and coursed stone, the wine cellar backed into the hillside to allow wagons to deliver grapes to the third floor for crushing and fermenting; the first and second floors were for wine storage. The 33 semi-circular arched windows have a molded arched trim with a center keystone. The semi-circular arched doorways were wide enough to allow a wagon to pass through. A stonewall to the south of the cellar connected with a stone "still house," which is a distillery for making brandy. T.L. Grigsby, originally from Tennessee, was one of the earliest settlers in Napa County. His farm surrounding the wine cellar was diversified as were most at that time. The builder was J.P. White.

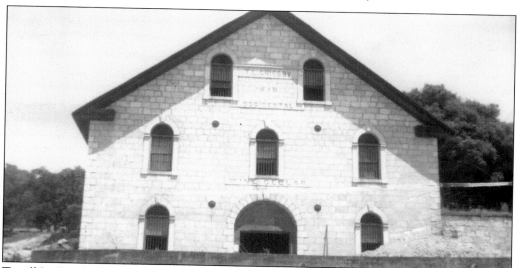

Terrill L. Grigsby built the Occidental Wine Cellar on the Silverado Trail. This pioneer had a dream: in his vineyard business, he wanted a wine cellar, and so he constructed one. It was 58 feet by 112 feet, and was three storied. It was built of native stone from the adjacent hills, and its capacity was estimated to be 275,000 gallons. The first two floors were for storage and the top floor for fermentation. The windows were iron-barred and the walls were 2-feet thick. The uprights were of heavy redwood. The wine cellar was located east of Silverado Trail, a half mile north of what is now Chimney Rock Golf Course. The building now stands as a monument to the memory of Terrill L. Grigsby.

On July 18, 1888, Horace Blanchard Chase, age 29, married Mary Ysabel Mizner, age 26. Horace (1859–1945) and Mary (1862–1923) created Stags Leap manor in the heart of the Stags Leap District of Napa County. Horace and Mary had met at Napa Soda Springs located about seven miles north of Napa. It was then at the height of its popularity as a vacation spot for San Francisco's socially prominent matrons and their families, and well known for the magnificence of its buildings, the efficacy of its springs, and the excellence of its cuisine.

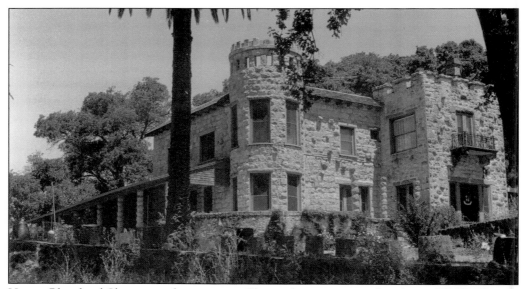

Horace Blanchard Chase, son of a prominent Chicago businessman and nephew of W.W. Thompson, well-known merchant and developer of Napa City in the mid-l9th century, built Stags' Leap as his country estate in 1888–1890. The estate became a social Mecca for San Francisco society in which Horace and his wife, Minnie, played a large role. The residence at 6150 Silverado Trail of native cut stone, the winery of fieldstone, the carriage house of pebble stone, and various outbuildings, cabins, etc. exhibiting a wide range of stone masonry technique, create an unusual cluster of buildings demonstrating the mason's art, which was highly developed in Napa County during this period. The house is a vernacular rendition of an English manor with originally two stories of cut stone and the third of wood, which has been removed leaving a crenellated corner tower and battlements. One of two original verandas remains with stone columns. Windows are narrow of one-over-one sash. In the 1920s the Grange family converted the house to a hotel.

Windy Flat (1870), 3701 Monticello Road, near the entrance to Wooden Valley, provided a resting place for freight teams hauling supplies, grain, etc. to and from Berryessa Valley over the rugged escarpment that divides Napa Valley from Berryessa Valley. The Monticello Road was the main link between Napa City and the town of Monticello, now covered by Lake Berryessa. Serving the teams at Windy Flat were the owners of the one story hip roofed cottage still visible. The original barns to one side are gone now. The house provided meals for the Berryessa traffic. Well into the early-20th century, Windy Flat would be filled with grain wagons and mule teams. There is now a modern restaurant for travelers.

Man With the Pipe is Napa County's "Man for all Seasons." Ever vigilant, he is a silent, solitary sentinel for all who have passed under his watchful eye for over a century and a half. In 1911, a group of young men gave him a pipe to help him while away the long hours. Not too long ago, it was stolen, but soon located and put back in his mouth by Cal-Trans.

The Soda Hole on Soda Creek in Soda Canyon is a natural landmark representative of the many "swimming holes" providing recreation along Napa County's creeks and Napa River. Soda Creek has formed a natural slide in bedrock and a classic swimming hole. The scenic appeal of the Soda Hole brought guests from the Jackson Napa Soda Springs, one of the most famous of Napa County's 19th-century mineral spas, on excursions to the site. During the late 19th century, a circular cavity was chiseled from bedrock adjacent to the Soda Hole to collect spring water, presumably for the guests to drink.

OPPOSITE: Napa Soda Springs at Soda Canyon Road, at its height in the 1880s and 1890s under the ownership of Col. J.P. Jackson, was one of the most fashionable spas on the West Coast. Nearly a century later the stone buildings of the spa are in ruins but these ruins carry an aesthetic value often compared to that of the ruins of Greece and Italy. Amos Buckman and Charles Allen first developed the 27 mineral springs in the late 1850s in the bottling of "Napa Soda." Colonel Jackson, builder of several railroads and developer of steamer lines, involved in silver mining, part owner of the *San Francisco Chronicle*, and later Collector of the Port of San Francisco, acquired the Napa Soda Springs in 1872. He immediately began construction of the native stone buildings, stone bottling works, and formal gardens, which made the spa renowned. The stone was taken from the ridge above the Springs. Colonel Jackson died in 1900, and with World War I came the end of the resort era in Napa County. Remnants of the formal gardens remain, as do the springs.

118

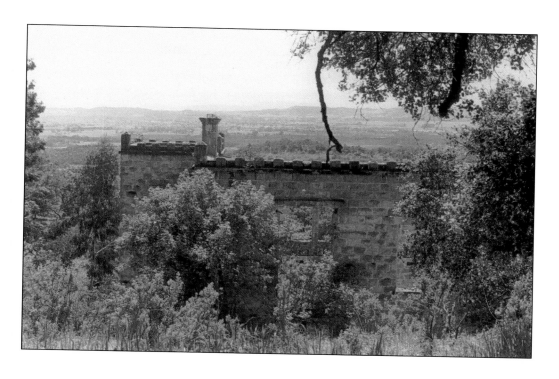

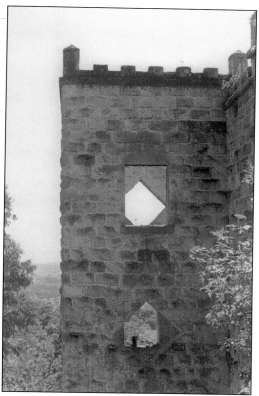

The Napa Soda Springs Rotunda was the crowning example of the native volcanic stone buildings erected by Col. J.P. Jackson at his Napa Soda Springs resort in the late-19th century. The vast and unique circular rotunda epitomized the now vanished elegance of this great resort. The rotunda was completed c. 1880. Originally built as stables, the stone building is 120 feet in diameter. The conical roof with a glass cupola was destroyed by fire in the mid-19th century. Built on the hillside, the rotunda was four stories in height and stands as the most southerly of the Napa Soda Springs ruins. The rotunda was converted to a ballroom, guest rooms, and office upon completion. Eucalyptus trees, planted as part of the early formal gardens, now encroach upon the rotunda ruin, which still commands a view of the Napa Valley.

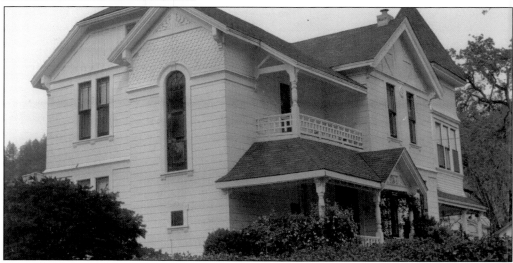

Mrs. Ellen G. White, one of the early founders of the Seventh Day Adventist Church and a strong advocate of its educational and medical efforts in the West, pioneered the establishment of the Healdsburg Academy in 1882 and its successor, Pacific Union College in Angwin in 1909. Through her efforts, the St. Helena Hospital (originally the Rural Health Retreat) was established in 1878 and Loma Linda University near Riverside, one of the largest medical universities in the West, was begun in the early 1900s. Her base was this Queen Anne style home at 125 Glass Mountain Lane, Deer Park, a few miles from Pacific Union College from the early 1900s to 1915. The house originally belonged to the Coolidge-Pratt family; W.A. Pratt, a wealthy landowner and Adventist, donated the site of the St. Helena Hospital. Unaltered, the house has many of the decorative characteristics of the Queen Anne: multi-gabled roof; varying surface textures of shiplap, shingle and carved panels; stick work; and prominent corner tower. Turned columns support the first and second story porches of the two and one-half story house. Note the fine arched stained glass window and pediment over the entryway. The setting and gardens remain undisturbed.

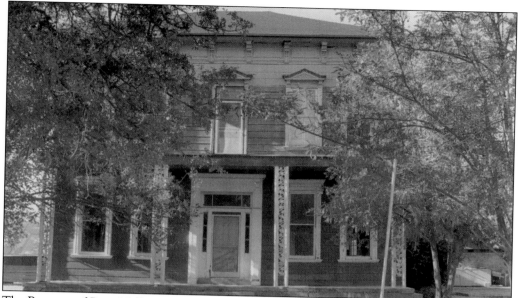

The Barnetts of Pope Valley were among the first settlers of this ranching area of eastern Napa County. E. Barnett, from Kentucky, joined one of the first parties west in 1841 and was with Yount in 1843. His son, wagon maker Jesse Barnett, arrived in Pope Valley in 1854 and his son, E.J. Barnett, continued to farm, raise stock, and manage the vineyard. The Barnett House (1885) on Barnett Road is Italianate in character with the symmetrical facade and bracketed cornice associated with the style. The doorway, with its transom and sidelights, is more often associated with the earlier Greek Revival style. Note the window hoods with a squeezed pediment on the second floor and a shelf lintel on the first floor. The two-story residence with shiplap siding has a later one-story addition to the rear. The front porch has also been altered. A stone outbuilding with a frame second story stands to the side of the house. The Barnett House still stands on a knoll not far from the creek in its original setting.

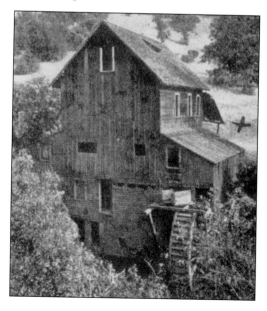

Construction of the Chiles Mill began in 1845 prior to construction of the Bale Mill (still standing) and was the first flour-mill in Napa County. It operated until the 1880s. Nothing remains of the mill, which was on the north side of Chiles and Pope Valley Road (historical landmark marker #547, on the south side of the road, marks the site). The three-story frame flourmill had an overshot wheel to which water from the creek was carried by wooden flumes. The wheel itself was below the level of the ground floor of the mill.

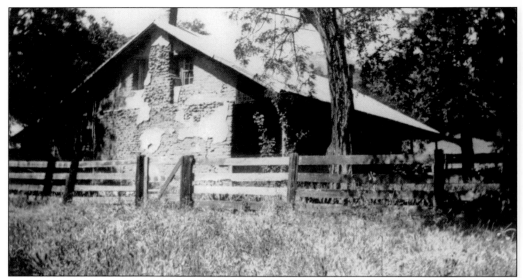

Joseph Ballinger Chiles, who first came to California in 1841 with the Bidwell-Bartleson party, the first emigrant train to enter California by way of the Sierra Nevada, built the Chiles Adobe at 3322 Chiles and Pope Valley Road. It is one of only two adobe structures remaining in Napa County. In 1844 he was granted the Catacula rancho, on which the adobe stands, by Manuel Micheltorena, Mexican governor of California. The adobe, a restored one and one-half story rectangular house with adobe walls and a gable roof, has an open porch under the overhanging roof supported by square posts. Original roof beams, porch posts, and other materials have been used as much as possible or duplicated in the renovation. Exterior walls have been coated with a protective white surface. A glassed-in sunroom has been added to the rear.

Raney Rock on Highway 128 near Highway 121 in Capell Valley is a natural outcropping in Capell Valley, which has served in the last century as a landmark in traveling from Napa to Monticello and now to Lake Berryessa. The Raney family, originally from Kentucky, were early settlers in this eastern part of Napa County. T.F. Raney served as county assessor in 1860. A.J. Raney served as county supervisor at the turn of the century when many of the stone bridges in the county were built. His role in early transportation is evident in his supervision of the building of the road from Napa to Monticello, Monticello Road, in the early 1900s. The alternate name for Raney Rock, "Sleeping Lady," is taken from the appearance of the rock in silhouette.

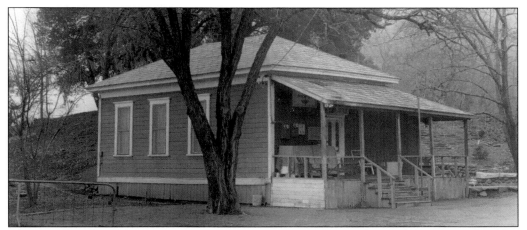

The Capell Valley School, 1191 Highway 128, appears today much as it did in the early 1900s when such one-room schoolhouses were common in Napa County. Erected c. 1898, it was the only school for Capell Valley until 1962 when a new school was built. The interior of the building retains its original woodwork and appearance. Capell Valley had its own school district and the community built the school on land donated by Thomas Jefferson Bradshaw to replace an earlier school that had burned. The one-story, hip-roofed school had the cloakrooms near the front door. In the late 1930s, the cloakroom became a bathroom. Quarters were also partitioned off in the 1930s to provide two rooms for the teacher to live in. The porch was added in 1905. The original double-hung windows and shiplap siding remain. Redwood timbers laid on the ground formed the foundation.

Walters Springs, 2950 Pope Canyon Road, is reminiscent of the many small resorts that clustered around the mineral springs of Napa County in the late-19th and early-20th centuries. A hotel, bathhouse, dining room/kitchen, and six cottages were erected in 1881. The two-story wood hotel/dining room/kitchen remains in fair condition. A two-story porch with balcony was added at a later date. On the earliest cottages, all are deteriorated or in ruins, though some dwelling units constructed more recently can be occupied. The carbonated mineral springs of the resort still flow, but the frame-bottling house has long been dismantled. J.J. Walters discovered the two springs in 1871, but they were not developed as a health resort until 1881 when he went into partnership with supervisor J.W. Smittle of Berryessa. In the early years, many people would bring tents and spend several weeks at the springs.

For nearly a century, the Pope Valley Store (1875) at the corner of Pope Valley Road and Howell Mountain Road was the center of activity for residents of Pope Valley. In the best tradition of country stores, it was the site of the post office, food and hardware store, hotel, bar, and in later years, the garage for the Valley. It stands today, at the crossroads of Pope Valley, little changed over the past 80 years. The store began in the 1870s in a one-story, wood, gable-roofed building. In the 1880s, a second one-story gable-roofed building was attached. In 1912, Thomas L.G. Neil bought the store from Henry Schaeffer and added a second story to the 1880s addition.

The Henry Haus Blacksmith and Wagon Maker Shop at the corner of Pope Valley Road and Howell Mountain Road is a unique reminder of the days when every community was dependent upon its blacksmith and wagon maker. It is the only known blacksmith shop remaining today in Napa County in an unaltered condition in its original setting. Located at the crossroads of upper Pope Valley, the shop is near the Pope Valley Store which served as hotel, post office, and bar as well. Of board and batten construction with a simple gable roof, the shop was built over a creek. A lean-to extension appears to have been added at an early date. Shading the site is a large oak. The Haus family, Ed, Henry, Otto, and August, were German Swiss and originally settled in Texas before coming to California. The older brothers were accomplished smiths and stonemasons in Europe; Henry learned the blacksmith trade here.

The Pope Valley Winery, 6613 Pope Valley Road, is one of the few three-story gravity flow wineries remaining in California. It represents the traditional winery architecture of the late-19th and 20th centuries. The original design is essentially unaltered although there have been alterations to the tin roof and siding of the second and third floor. In 1909, the Haus family built the winery of redwood timbers salvaged from the Oat Hill Mine, the 1880s quicksilver mine accessible from Pope Valley. The winery was built into a hillside of ledge rock, which had been blasted out. The rough interior stonewalls remain as do the exposed timber construction and board and batten siding. Sam Haus and his sister Lily operated the winery until 1959.

Litto's Place (1942), 6654 Pope Valley Road, is an expression of 20th century environmental folk art. Emanuele "Litto" Damonte has covered his small frame house, garage, sheds, trees, and fences with the "found" objects of country roads, attics, and basements. Chrome bumpers and hubcaps are immediately eye-catching; painted tires, pinwheels, birdhouses, and machinery parts are all arranged for maximum glitter and pattern. In recent years Litto has created more wind objects and his place has taken on a kinetic effect. Litto Damonte, originally from Italy, worked as a concrete finisher in San Francisco. In the early 1940s he moved to Pope Valley and constructed the first cement, tire, and rock barriers to protect his driveway. Hubcaps warned of the barriers. Children and neighbors added to the collection and the folk art environment has grown over the years under Litto's hand.

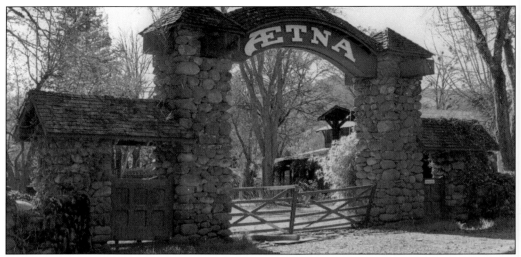

Aetna Springs, 1621 Aetna Springs Road, achieved California fame in the mid-19th century for its quicksilver mines and in the late-19th century as a mineral spa. It is unique in that its complex of 30-plus late-19th and early-20th century structures stand remarkably unaltered reflecting the early design influences of architects Bernard Maybeck and Albert Farr in the first decades of the Bay Area Tradition. Within Napa County, only Napa Soda Springs shared the stature of Aetna Springs during the resort/spa era and it is now in ruins. In 1867, the first quicksilver mining claims were taken on the Springs area. Mine flooding and falling prices ended mining in 1877. That year, Chancellor Hartson, a well-known Napa financier, began development of the springs as a spa. Aetna Mineral Water, bottled at the site, was eventually distributed throughout the western states. In the 1890s, under new owner Len Owens, major architectural improvements to the site carried the imprint of Maybeck and Farr.

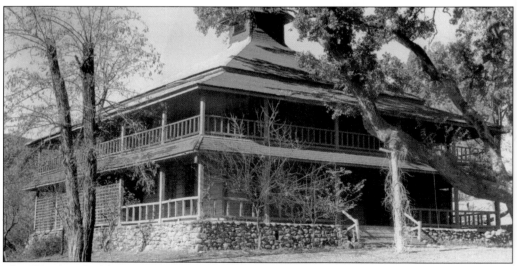

The Winship Building is probably the earliest lodging building at Aetna Springs, originally constructed c. 1880, and is distinctive for its two-story height and central cupola from which "a splendid view of the grounds could be had" (1893). Soon after Len Owens acquired the property in 1891, the Winship Building was moved to its present location from the site of the Social Hall and remodeled.

126

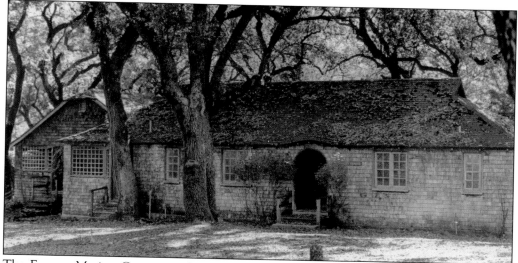

The Frances Marion Cottage at Aetna Springs merges with the bank of Aetna Creek. The famed resort drew many from the social circles of San Francisco including a bohemian mixture from the art and literary worlds of the West Coast. Frances Marion, a screenwriter and author, was the daughter of Len Owens, owner of the spa from 1891 to 1944. The Frances Marion Cottage is one of several at Aetna Springs attributed to Albert Farr including the Caroline and the Gassaway. The shingled cottage with its distinctive arched and recessed doorway and casement windows is reminiscent of English country cottages.

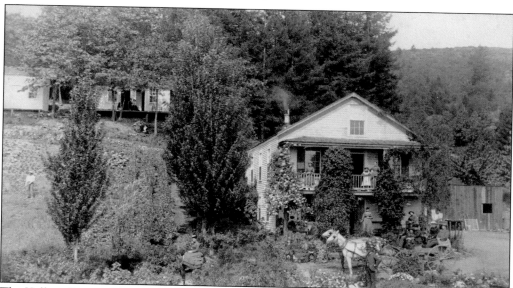

The Kellogg-Lyman House, adjacent to the Old Bale Mill at 3351 North St. Helena Highway, is believed to be the oldest frame structure in the Upper Napa Valley. It was constructed in 1849 as his residence by F.E. Kellogg, builder of the Bale Grist Mill. W.W. Lyman Sr. purchased the Kellogg ranch c. 1871 when he also acquired the mill. The Lyman family operated the mill until 1905 as well as the El Molino wine cellar, which they built in 1871 and operated until 1910. In 1921 W.W. Lyman Sr. died and in 1923, the family gave the Bale Mill to the Native Sons of the Golden West. It is now operated as a state historic park.

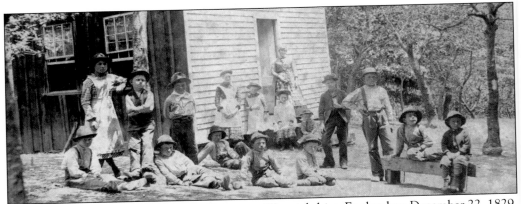

James Edward Elkington was born in Coventry, Warwickshire, England on December 22, 1829. He was the eldest of five children, four boys and one girl, all of whom, except the youngest boy, immigrated to America. At the age of eight he began working. His father William, who taught his sons the art of taxidermy, died when he was 13. James gave each of his children when they married a glass case containing Napa County birds that he had stuffed. His brother John had a taxidermy shop on Brown Street, Napa City in 1874. In 1853, at 24, he married Emma Clarke who was born in Gloucestershire, England. In 1855, after the birth of his son, James Edward Jr., he left for America. Emma and little James came to America, along with the James' mother Amelia and his brother John. They arrived in New London, Connecticut in 1857. The family resided in New London until the fall of 1864 when they boarded a ship for California. They crossed the Isthmus of Panama on a mule train and boarded another ship bound for San Francisco, arriving there in February 1865. They remained in San Francisco for over a year, and then James moved his family to the Mt. Veeder property where he and his wife built up a popular Mt. Veeder Resort, while raising another five children; one being born in San Francisco and the other four born at the Mt. Veeder home.

The children attended the Lone Tree School, a one-room schoolhouse in the redwoods. Three of the five girls were married in the family home. After selling the resort, James and Emma moved to Napa City and built another fine home on Calistoga Avenue. James and his sons invested in the Napa Woolen Mills and lost their investments in a fire, which totaled the building completely and damaged the Napa Woolen Mills along side of it. Having no insurance James worked again on a threshing machine that following summer in order to pay off some of his debts. As James grew older, he gave his home, in a trust, to the Advent Christian Church. He and wife Emma and most of his family were very active in this church and the boys and their father helped build the church in Napa on Second Street. James died on October 28, 1898 in Napa and is buried at Tulocay Cemetery along with his mother Amelia (1891), and wife Emma (1919) in the Elkington family plot.